Video Basics 7
Workbook

Video Basics 7 Workbook

Herbert Zettl

San Francisco State University

WADSWORTH
CENGAGE Learning·

Australia · Brazil · Japan · Korea · Mexico · Singapore · Spain · United Kingdom · United States

WADSWORTH
CENGAGE Learning·

ISBN-13: 978-1-111-83710-5
ISBN-10: 1-111-83710-4

Wadsworth Cengage Learning
20 Davis Drive
Belmont, CA 94002-3098
USA

Cengage Learning products are represented in Canada by Nelson Education, Ltd.

For your course and learning solutions, visit **www.cengage.com**.

Purchase any of our products at your local college store or at our preferred online store **www.cengagebrain.com**.

Cover Images: Edward Aiona (people) and Panasonic (camera)

Printed in the United States of America
2 3 4 5 6 19 18 17 16 15

*To all students who are smart enough to study this important discipline
and responsible enough to polish their skills.*

*This workbook is meant not to show you up for what you don't know
but to help you identify what you still need to learn.*

Contents

Preface

The primary objective of *Video Basics 7 Workbook* is to reinforce students' learning, aid their recall of terminology and production processes, and help them bridge as much as possible the gap between reading and doing.

To make my remarks maximally relevant, I have divided them into "for the student" and "for the instructor" sections.

FOR THE STUDENT

Attitude For some reason, workbooks are often the least-favorite learning instrument—to put it mildly. I suppose it is because if you know all the answers, filling in the bubbles seems like a waste of time, and, if you don't know the answers, the wrong bubbles show all too clearly what you still have to learn. But let me assure you that doing your *Workbook* assignments conscientiously and punctually will greatly help you become a video production professional, even if initially you may not think so or be aware of it.

Independent of text When answering the various problems, you might be tempted to simply open the textbook and copy the readily available answers to the *Workbook* questions. But this will not speed up your learning process. What *will* facilitate learning is to answer the questions independently. In this context the *Workbook* lets you practice retrieval of the knowledge you have acquired by reading the text. As you well know, the value of learning is not so much what you stuff into your head but what comes out of it on demand. In video production you are constantly challenged not only to perform at a high level of competency day in and day out but also to come up with fresh ideas on demand.

FOR THE INSTRUCTOR

Learning objectives All of the problems in the *Workbook* are structured with these specific learning objectives in mind:

- *To reinforce the learning of video terminology, production tools, and production procedures and techniques.* The review of the key terms and the multiple-choice questions are to test students' knowledge of the terminology and the basic tools of video production—what they are and how they work. These

exercises are to check student comprehension. If students have no trouble matching the key terms with their definitions and can answer the multiple-choice questions with relative ease without having to look up the answers in *Video Basics 7,* they have successfully learned the required material. The Problem-Solving Applications test whether students can apply the material in a variety of hypothetical production contexts. The final and most important criterion is, of course, whether students can apply the basic techniques in an actual video production.

▓ *To facilitate the retrieval of information when needed.* By completing the review sections without looking up any answers, students will quickly discover their strong and weak points. After pinpointing their strengths and weaknesses, they can go back to the text and, if available, to *Zettl's VideoLab 4.0* DVD-ROM and remedy their deficiencies.

▓ *To facilitate the efficient and effective application of video production equipment and practices.* The multiple-choice questions test students on what they should do—and how to do it—in various production situations. *Zettl's VideoLab 4.0* DVD-ROM offers students further opportunities to practice in the Try It and Quiz sections.

▓ *To find creative solutions to production problems.* As mentioned, the Problem-Solving Applications challenge students to come up with creative solutions to common production problems. Note that the problem-solving section invites various answers, depending on the specific production context or available equipment. In solving these problems, students should, at least initially, not feel limited by budget and time restrictions. The floor plan and storyboard sheets are included to visualize sets, shots, and shot sequences and to make the format relatively uniform.

Diagnostic instrument As an instructor, you can use the *Workbook* as a convenient diagnostic tool—to find out not so much what students know but what they *don't* know or can't readily recall. This lets you focus on certain production areas that need attention and assign appropriate field and studio production activities to make up for the deficiencies.

Objective assessment The *Workbook* provides you with an objective tool for assessing student comprehension of the language of video production, the basic production techniques, and how to apply certain techniques in a variety of production contexts.

Organization This edition of the *Workbook* closely follows the chapter sequence of the *Video Basics 7* text. As in the main text, the unique characteristics and the production requirements of digital television are emphasized throughout the *Workbook*. Despite this close correlation, however, the *Workbook* chapters are self-contained and can be assigned independently and in any order desired.

The *Workbook* review sections correspond with the headings of each chapter. Except for the Problem-Solving Applications, which are primarily designed for in-class discussion, all review problems can be answered by filling in specific bubbles rather than writing in the correct information. This is done primarily to help you reduce the time needed to correct the *Workbook* assignments but also to establish an objective grading breakdown.

Answer key to *Workbook* problems The answer bubbles are continuously numbered within each chapter to stamp each problem with a unique address. This allows computer scanning and grading if desired. You may save time, however, by simply checking the answers against the *Answer Key* in the *Instructor's Manual for Video Basics 7*, which includes suggestions for how to check the bubble answers most efficiently by hand.

ACKNOWLEDGMENTS

Once again, my first thanks go to the people at Wadsworth/Cengage Learning who insisted on a workbook that is as efficient in its use as it is effective in student learning. My thanks go especially to Gary Palmatier of Ideas to Images for his transparent layout and clear illustrations and to Elizabeth von Radics for her precise editing; their contributions eliminated possible ambiguities and greatly assist students in achieving the learning objectives.

I am also indebted to my colleagues at San Francisco State University and other institutions, and especially to my students, who helped me refine the problems directly or indirectly by asking questions, by making mistakes I expected, and by finding solutions I did not expect.

Special thanks go to my wife, Erika, who as a longtime classroom teacher, administrator, and educational consultant helped me clarify the questions and objectify the answers without impinging too much on students' creativity.

Herbert Zettl

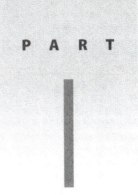

Production:
Processes and People

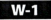

Production Process

REVIEW OF KEY TERMS

Match each term with its appropriate definition by filling in the corresponding bubble.

1. postproduction
2. production
3. multicamera production
4. angle
5. medium requirements
6. single-camera production
7. program objective
8. preproduction

A. The basic point of view that dominates the approach to a story

A
○ ○ ○ ○
1 2 3 4
○ ○ ○ ○
5 6 7 8

B. The desired effect of a program on the viewer

B
○ ○ ○ ○
1 2 3 4
○ ○ ○ ○
5 6 7 8

C. The equipment, facilities, and people necessary for a specific production

C
○ ○ ○ ○
1 2 3 4
○ ○ ○ ○
5 6 7 8

D. Production activities after the video-recording phase

D
○ ○ ○ ○
1 2 3 4
○ ○ ○ ○
5 6 7 8

PAGE
TOTAL

1. postproduction
2. production
3. multicamera production
4. angle
5. medium requirements
6. single-camera production
7. program objective
8. preproduction

E. Activities during the planning of a production

E ○ ○ ○ ○
 1 2 3 4
 ○ ○ ○ ○
 5 6 7 8

F. The use of several cameras for the simultaneous video recording of an event

F ○ ○ ○ ○
 1 2 3 4
 ○ ○ ○ ○
 5 6 7 8

G. A film-style approach to video recording

G ○ ○ ○ ○
 1 2 3 4
 ○ ○ ○ ○
 5 6 7 8

H. Activities during which the production is telecast live or recorded

H ○ ○ ○ ○
 1 2 3 4
 ○ ○ ○ ○
 5 6 7 8

PAGE TOTAL

SECTION TOTAL

REVIEW OF PRODUCTION MODEL

1. Identify each part of the production model diagram and fill in the bubbles with the corresponding numbers.

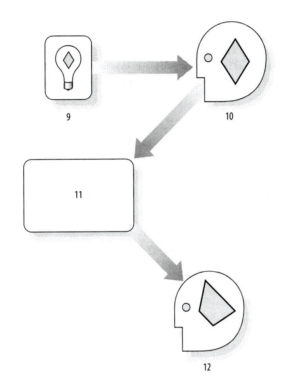

9

10

11

12

a. desired effect

1a ◯ ◯ ◯ ◯
 9 10 11 12

b. message actually received

1b ◯ ◯ ◯ ◯
 9 10 11 12

c. basic idea

1c ◯ ◯ ◯ ◯
 9 10 11 12

d. medium requirements

1d ◯ ◯ ◯ ◯
 9 10 11 12

P A G E
T O T A L

Select the correct answers and fill in the bubbles with the corresponding numbers.

2. Medium requirements are basically determined by (13) *the program objective* (14) *the chief engineer* (15) *the available equipment.*

2 ◯ ◯ ◯
 13 14 15

3. The medium requirements include (16) *equipment and people* (17) *equipment, production elements, and people* (18) *equipment but not program content and people.*

3 ◯ ◯ ◯
 16 17 18

4. The closer the actually received message is to the (19) *program objective* (20) *producer's objective* (21) *medium requirements,* the more successful the program.

4 ◯ ◯ ◯
 19 20 21

5. The message that ultimately counts is the one that is (22) *transmitted by the originating institution* (23) *carefully constructed by the producer* (24) *received and interpreted by the viewer.*

5 ◯ ◯ ◯
 22 23 24

6. The most important initial step in the production model is to (25) *determine the available production equipment* (26) *define the program objective* (27) *contact production personnel.*

6 ◯ ◯ ◯
 25 26 27

7. The "angle" describes (28) *the basic approach to the production* (29) *a critical view of the program objective* (30) *the point of view of the audience.*

7 ◯ ◯ ◯
 28 29 30

PAGE
TOTAL

SECTION
TOTAL

REVIEW OF PRODUCTION PROCESSES

Select the correct answers and fill in the bubbles with the corresponding numbers.

1. In the preproduction flowchart below, match each major step with the corresponding number.

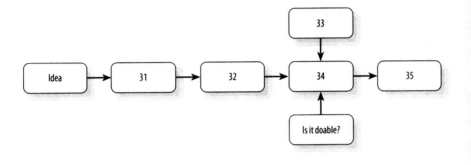

a. evaluation

1a ○ ○ ○ ○ ○
31 32 33 34 35

b. script

1b ○ ○ ○ ○ ○
31 32 33 34 35

c. program objective

1c ○ ○ ○ ○ ○
31 32 33 34 35

d. angle

1d ○ ○ ○ ○ ○
31 32 33 34 35

e. Is it worth doing?

1e ○ ○ ○ ○ ○
31 32 33 34 35

PAGE
TOTAL

2. In the preproduction flowchart below, match each major step with the corresponding number.

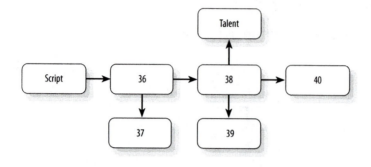

a. facilities/equipment/tech personnel

2a ○ ○ ○ ○ ○
 36 37 38 39 40

b. budget

2b ○ ○ ○ ○ ○
 36 37 38 39 40

c. director

2c ○ ○ ○ ○ ○
 36 37 38 39 40

d. art director

2d ○ ○ ○ ○ ○
 36 37 38 39 40

e. producer

2e ○ ○ ○ ○ ○
 36 37 38 39 40

REVIEW OF CONVERGENCE OF STUDIO AND FIELD PRODUCTION

1. Fill in the bubbles whose numbers correspond with the appropriate camera setup as shown in the diagrams below and on the following page.

 a. multicamera iso

 1a ◯ ◯ ◯
 41 42 43

 b. multicamera switched

 1b ◯ ◯ ◯
 41 42 43

 c. single-camera film-style

 1c ◯ ◯ ◯
 41 42 43

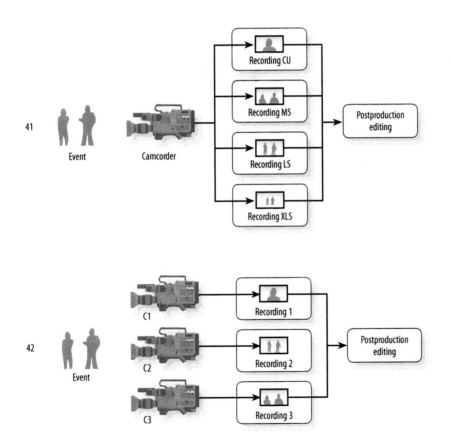

SECTION TOTAL

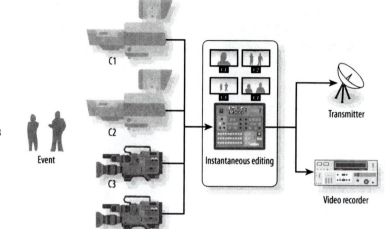

43

Event

C1

C2

C3

C4

Instantaneous editing

Transmitter

Video recorder

REVIEW QUIZ

*Mark the following statements as true or false by filling in the bubbles in the **T** (for true) or*
***F** (for false) column.*

		T	F
1.	The signals of a multicamera setup can be fed into the switcher or into separate recorders for each camera.	**1** ◯ 44	◯ 45
2.	The program objective is important for the preproduction phase and the production phase but not the postproduction phase.	**2** ◯ 46	◯ 47
3.	In the context of preproduction, an "angle" means a specific camera field of view.	**3** ◯ 48	◯ 49
4.	Successful brainstorming requires a discussion leader who prevents irrelevant ideas.	**4** ◯ 50	◯ 51
5.	Clustering and brainstorming are similar idea-creating techniques.	**5** ◯ 52	◯ 53
6.	Medium requirements include production personnel, equipment, and facilities.	**6** ◯ 54	◯ 55
7.	Because production is primarily a creative activity, any type of production system would prove counterproductive.	**7** ◯ 56	◯ 57
8.	The preproduction process includes the statement of the medium requirements.	**8** ◯ 58	◯ 59
9.	The audience is largely irrelevant when establishing the program objective.	**9** ◯ 60	◯ 61
10.	When brainstorming for new ideas, somebody should make sure that the ideas generated are always relevant to the topic.	**10** ◯ 62	◯ 63

SECTION
TOTAL []

PROBLEM-SOLVING APPLICATIONS

1. Do a brainstorming session. Have several people engaged in the same production problem sit in a circle, then place the mic of a small audiotape recorder in the center of the circle. Describe the general theme of the production, such as "improving education in this country" or "the importance of art in elementary schools." Do not try to state the general idea as a program objective. The specific program objective should develop out of the brainstorming session.

 A good way to begin is to have one of the group members say something neutral, such as "Knock-knock-who's there?" or "Hello, what can I do for you?" Make sure that *all* ideas are accepted and not commented on, however far-out or ridiculous they may seem. During the playback you can be more discriminating and select only those ideas that fit your overall production theme. See whether, and how, this material might help you design a program objective and/or the medium translation of the objective.

2. Select a key word signifying your program theme and do an idea cluster. Use the cluster to develop the program objective, the specific program type (interview, documentary, or drama), and the production approach (studio, ENG, EFP, single-camera, or multicamera).

3. The producer who leads the brainstorming session for new show ideas says that she doesn't have to audio-record all the comments because she is writing down the relevant ones anyway. Do you agree with her?

4. In a follow-up session to define the program objective, the art director says not to worry about cameras, microphones, or even budgets right now but rather to focus on what the viewers should get out of the program. Do you agree with him? Be specific.

5. Expand the clusters indicated in the following three figures and develop a precise program objective from each.

Production Team: Who Does What When?

REVIEW OF KEY TERMS

Match each term with its appropriate definition by filling in the corresponding bubble.

1. time line
2. production team
3. postproduction team
4. EFP team
5. technical personnel
6. preproduction team
7. nontechnical production personnel
8. production schedule

A. A calendar that lists major production activities

A ○ ○ ○ ○
 1 2 3 4
 ○ ○ ○ ○
 5 6 7 8

B. Consists of director, video editor, and sometimes sound designer

B ○ ○ ○ ○
 1 2 3 4
 ○ ○ ○ ○
 5 6 7 8

C. Consists of a variety of nontechnical and technical people, such as the producer and various assistants (associate producer and PA), the director and assistant, and the talent and production crew

C ○ ○ ○ ○
 1 2 3 4
 ○ ○ ○ ○
 5 6 7 8

D. A schedule that shows the time allotment for various activities during the production day

D ○ ○ ○ ○
 1 2 3 4
 ○ ○ ○ ○
 5 6 7 8

PAGE TOTAL []

1. time line	4. EFP team
2. production team	5. technical personnel
3. postproduction team	6. preproduction team

7. nontechnical production personnel
8. production schedule

E. Category for crew members such as camera operators, floor persons, and audio engineers

E ○ ○ ○ ○
　 1　2　3　4
　 ○ ○ ○ ○
　 5　6　7　8

F. Usually the talent, camcorder operator, and utility person

F ○ ○ ○ ○
　 1　2　3　4
　 ○ ○ ○ ○
　 5　6　7　8

G. Category for personnel such as producers, directors, and talent

G ○ ○ ○ ○
　 1　2　3　4
　 ○ ○ ○ ○
　 5　6　7　8

H. Consists of people who plan the production, normally including the producer, director, writer, art director, and technical supervisor or technical director; large productions may also include a composer and a choreographer

H ○ ○ ○ ○
　 1　2　3　4
　 ○ ○ ○ ○
　 5　6　7　8

PAGE TOTAL

SECTION TOTAL

REVIEW OF PRODUCTION PERSONNEL AND RESPONSIBILITIES

Identify the person mainly responsible for the following production situations and fill in the bubbles with the corresponding numbers.

1. Last-minute changes to the names on the final credits are made by the (9) *art director* (10) *CG operator* (11) *TD.*

 1 ◯ 9 ◯ 10 ◯ 11

2. Making sure that the dancers can hear the music recording is the responsibility of the (12) *LD* (13) *AD* (14) *audio engineer.*

 2 ◯ 12 ◯ 13 ◯ 14

3. The person in charge of camera rehearsals is the (15) *AD* (16) *director* (17) *TD.*

 3 ◯ 15 ◯ 16 ◯ 17

4. Informing talent and crew about a production schedule change is the responsibility of the (18) *floor manager* (19) *producer* (20) *TD.*

 4 ◯ 18 ◯ 19 ◯ 20

5. Arranging various shots in postproduction is done by the (21) *producer* (22) *video operator* (23) *editor.*

 5 ◯ 21 ◯ 22 ◯ 23

6. The talent wants to make sure that he can see the opening cues. He should talk to the (24) *director* (25) *producer* (26) *floor manager.*

 6 ◯ 24 ◯ 25 ◯ 26

7. Having the scenery set up and the set decorated by the scheduled time is the responsibility of the (27) *TD* (28) *director* (29) *floor manager.*

 7 ◯ 27 ◯ 28 ◯ 29

8. The producer complains about the "static look" of the set. To correct the situation, she must talk to the (30) *TD* (31) *art director* (32) *executive producer.*

 8 ◯ 30 ◯ 31 ◯ 32

9. To increase the overall light level in a scene, you should ask the (33) *LD* (34) *PA* (35) *floor manager.*

 9 ◯ 33 ◯ 34 ◯ 35

10. The time line is done by the (36) *floor manager* (37) *director* (38) *art director.*

 10 ◯ 36 ◯ 37 ◯ 38

SECTION TOTAL []

From the list below, select the major items omitted from the following time line and fill in the corresponding bubbles. **Note: This list contains items that are not part of the customary time line.**

Time Line: April 15 — Panel Discussion (Studio 1)

8:30–9:00 a.m.	Tech meeting
9:00–11:00 a.m.	Setup and lighting
12:00–12:15 p.m.	Notes and reset
12:15–12:30 p.m.	Briefing of panel guests
12:30–12:45 p.m.	Run-through and camera rehearsal
12:45–12:55 p.m.	Notes and reset
12:55–2:55 p.m.	Recording
2:55–3:30 p.m.	Spill

(39) *tech meeting*

(40) *reset*

(41) *crew call*

(42) *preproduction meeting*

(43) *strike*

(44) *lighting*

(45) *break*

(46) *camera rehearsal*

(47) *recording*

(48) *meal*

(49) *budget meeting*

(50) *notes*

○ ○ ○ ○
39 40 41 42

○ ○ ○ ○
43 44 45 46

○ ○ ○ ○
47 48 49 50

SECTION
TOTAL

REVIEW QUIZ

*Mark the following statements as true or false by filling in the bubbles in the **T** (for true) or*
***F** (for false) column.*

		T	**F**
1.	The director should have some influence on postproduction editing.	**1** ○ 51	○ 52
2.	The LD is in charge of directing the log entries.	**2** ○ 53	○ 54
3.	Talent includes actors and performers.	**3** ○ 55	○ 56
4.	The AD is involved in preproduction but not in production.	**4** ○ 57	○ 58
5.	The art director is responsible for putting up the studio set.	**5** ○ 59	○ 60
6.	The audio engineer works the audio console during a show.	**6** ○ 61	○ 62
7.	The floor manager is principally responsible for the budget.	**7** ○ 63	○ 64
8.	Normally, the TD runs the video recorder.	**8** ○ 65	○ 66
9.	The PA is usually responsible for notes.	**9** ○ 67	○ 68
10.	The executive producer is always part of the field survey team.	**10** ○ 69	○ 70
11.	The editor is part of the preproduction team.	**11** ○ 71	○ 72
12.	Principal camera positions and talent blocking are determined by the director.	**12** ○ 73	○ 74
13.	The director can be on the preproduction team as well as on the postproduction team.	**13** ○ 75	○ 76
14.	The TD is always part of the postproduction team.	**14** ○ 77	○ 78
15.	In a standard EFP, the TD can also function as the LD.	**15** ○ 79	○ 80

SECTION
TOTAL

PROBLEM-SOLVING APPLICATIONS

1. The camera operators for a weekly two-camera interview series tell you, the producer, that they do not need a director because they have done the show many times and know every shot by heart. Do you agree? If so, why? If not, why not?

2. The ENG/EFP camcorder operator of a weekly on-location interview show tells you, the producer, that he does not need a director because he has done the show many times and knows what shots are required. Do you agree? If so, why? If not, why not?

3. The PA complains that the producer, the director, and even the floor manager ask her to write down specific production problems. Her comment is that, as a production assistant, she has to listen only to the producer. Is her complaint justified?

4. The talent complains to the director about the long hours and the relatively low pay. Is the talent complaining to the right person? If so, why? If not, to whom should the talent direct the complaints?

5. The novice director tells you, the AD, not to worry about the time line because he will move on to the next time block only when satisfied with rehearsing the current scene. Do you agree with him? If so, why? If not, why not?

P A R T

II

Image Creation: Digital Video and Camera

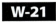

Course No. _____ Date _____ Name _____

Image Formation and Digital Video

REVIEW OF KEY TERMS

Match each term with its appropriate definition by filling in the corresponding bubble.

1. sampling
2. Super-Hi Vision
3. interlaced scanning
4. field
5. frame rate

6. 720p
7. progressive scanning
8. 1080i
9. frame
10. analog

11. codec
12. digital
13. HDTV
14. compression
15. scanning

A. The system that scans all odd-numbered lines and then all even-numbered lines

A
○ ○ ○ ○ ○
1 2 3 4 5
○ ○ ○ ○ ○
6 7 8 9 10
○ ○ ○ ○ ○
11 12 13 14 15

B. The scanning cycle of all odd or even lines

B
○ ○ ○ ○ ○
1 2 3 4 5
○ ○ ○ ○ ○
6 7 8 9 10
○ ○ ○ ○ ○
11 12 13 14 15

C. Data in an on/off configuration

C
○ ○ ○ ○ ○
1 2 3 4 5
○ ○ ○ ○ ○
6 7 8 9 10
○ ○ ○ ○ ○
11 12 13 14 15

PAGE
TOTAL []

1. sampling	6. 720p	11. codec		
2. Super-Hi Vision	7. progressive scanning	12. digital		
3. interlaced scanning	8. 1080i	13. HDTV		
4. field	9. frame	14. compression		
5. frame rate	10. analog	15. scanning		

D. A signal that fluctuates like the original stimulus

D ○ ○ ○ ○ ○
 1 2 3 4 5
 ○ ○ ○ ○ ○
 6 7 8 9 10
 ○ ○ ○ ○ ○
 11 12 13 14 15

E. A recording system that is used primarily for digital cinema

E ○ ○ ○ ○ ○
 1 2 3 4 5
 ○ ○ ○ ○ ○
 6 7 8 9 10
 ○ ○ ○ ○ ○
 11 12 13 14 15

F. The consecutive scanning from top to bottom

F ○ ○ ○ ○ ○
 1 2 3 4 5
 ○ ○ ○ ○ ○
 6 7 8 9 10
 ○ ○ ○ ○ ○
 11 12 13 14 15

G. The movement of the electron beam from left to right and from top to bottom

G ○ ○ ○ ○ ○
 1 2 3 4 5
 ○ ○ ○ ○ ○
 6 7 8 9 10
 ○ ○ ○ ○ ○
 11 12 13 14 15

H. Can be one of several compression systems of digital video, graphics, and audio files

H ○ ○ ○ ○ ○
 1 2 3 4 5
 ○ ○ ○ ○ ○
 6 7 8 9 10
 ○ ○ ○ ○ ○
 11 12 13 14 15

PAGE
TOTAL []

I. The temporary rearrangement or elimination of redundant picture information for more-efficient storage and signal transport

I
○ ○ ○ ○ ○
1 2 3 4 5
○ ○ ○ ○ ○
6 7 8 9 10
○ ○ ○ ○ ○
11 12 13 14 15

J. Selecting a great number of small parts of the analog signal at equally spaced intervals

J
○ ○ ○ ○ ○
1 2 3 4 5
○ ○ ○ ○ ○
6 7 8 9 10
○ ○ ○ ○ ○
11 12 13 14 15

K. The scanning system that consists of two 540-line fields (some claim that there are two 539½-line fields)

K
○ ○ ○ ○ ○
1 2 3 4 5
○ ○ ○ ○ ○
6 7 8 9 10
○ ○ ○ ○ ○
11 12 13 14 15

L. One of the accepted progressive scanning systems of DTV

L
○ ○ ○ ○ ○
1 2 3 4 5
○ ○ ○ ○ ○
6 7 8 9 10
○ ○ ○ ○ ○
11 12 13 14 15

M. The number of complete scanning cycles per second

M
○ ○ ○ ○ ○
1 2 3 4 5
○ ○ ○ ○ ○
6 7 8 9 10
○ ○ ○ ○ ○
11 12 13 14 15

N. A complete scanning cycle of the electron beam

N
○ ○ ○ ○ ○
1 2 3 4 5
○ ○ ○ ○ ○
6 7 8 9 10
○ ○ ○ ○ ○
11 12 13 14 15

P A G E
T O T A L []

1. sampling	6. 720p	11. codec
2. Super-Hi Vision	7. progressive scanning	12. digital
3. interlaced scanning	8. 1080i	13. HDTV
4. field	9. frame	14. compression
5. frame rate	10. analog	15. scanning

O. High-definition television

O ① ② ③ ④ ⑤
 1 2 3 4 5
 ⑥ ⑦ ⑧ ⑨ ⑩
 6 7 8 9 10
 ⑪ ⑫ ⑬ ⑭ ⑮
 11 12 13 14 15

PAGE
TOTAL

SECTION
TOTAL

REVIEW OF BASIC IMAGE FORMATION

Select the correct answers and fill in the bubbles with the corresponding numbers.

1. An interlaced television frame consists of (16) *two fields* (17) *three fields* (18) *four fields.*

 1 ◯ 16 ◯ 17 ◯ 18

2. Each scanning line is made up of (19) *pixels* (20) *numbers* (21) *digits.*

 2 ◯ 19 ◯ 20 ◯ 21

3. To produce a complete frame in the 720p system, you need to scan (22) *720 visible lines* (23) *2 fields* (24) *1,440 fields.*

 3 ◯ 22 ◯ 23 ◯ 24

4. In progressive scanning each scanning cycle produces a (25) *field* (26) *frame.*

 4 ◯ 25 ◯ 26

5. In progressive scanning (27) *only the odd-numbered lines are scanned* (28) *each line is scanned from top to bottom in sequence* (29) *only the even-numbered lines are scanned.*

 5 ◯ 27 ◯ 28 ◯ 29

6. The 1080i system can use (30) *only interlaced scanning* (31) *only progressive scanning* (32) *either interlaced or progressive scanning.*

 6 ◯ 30 ◯ 31 ◯ 32

7. To produce a color image, a television receiver needs (33) *one* (34) *two* (35) *three* color signals.

 7 ◯ 33 ◯ 34 ◯ 35

8. In the 1080i system, you need (36) *540* (37) *1,080* (38) *2* fields to complete each frame.

 8 ◯ 36 ◯ 37 ◯ 38

9. A 4K Super-Hi Vision display has approximately (39) *400* (40) *4,000* (41) *8,000* pixels per horizontal scanning line.

 9 ◯ 39 ◯ 40 ◯ 41

SECTION TOTAL ☐

REVIEW OF ANALOG AND DIGITAL PROCESSES

Select the correct answers and fill in the bubbles with the corresponding numbers.

1. A digital signal operates on the (42) *continuous wave* (43) *on/off* (44) *sine wave* principle.

1 ○ ○ ○
 42 43 44

2. Which of the two sampling rates shown below will produce the higher-quality signal?

2 ○ ○
 45 46

 45 46

3. The compression system that eliminates redundant digital information is called (47) *lossless* (48) *lossy* (49) *low-sampling.*

3 ○ ○ ○
 47 48 49

4. One of the chief advantages of a digital over an analog video signal is that the digital signal (50) *can be sampled* (51) *can be interlaced* (52) *can be dubbed many times without noticeable deterioration.*

4 ○ ○ ○
 50 51 52

5. The compression system that compares frames for redundant information is called (53) *CODEC-4* (54) *MPEG-2* (55) *JPEG-3.*

5 ○ ○ ○
 53 54 55

6. When digitizing for high quality, the sampling rate should be (56) *as high as possible* (57) *as low as possible* (58) *neither because sampling is not a digitizing step.*

6 ○ ○ ○
 56 57 58

7. The binary on/off code is normally represented by (59) *0's and 1's* (60) *1's and 2's* (61) *0's and 00's.*

7 ○ ○ ○
 59 60 61

SECTION TOTAL []

REVIEW QUIZ

*Mark the following statements as true or false by filling in the bubbles in the **T** (for true) or*
__F__ (for false) column.

			T	**F**

1. In progressive scanning, each scanning cycle from top to bottom generates a field. **1** ◯ 62 ◯ 63

2. Lossy compression is rarely used because it always leads to noticeable picture deterioration. **2** ◯ 64 ◯ 65

3. The digital signal fluctuates exactly like the original stimulus. **3** ◯ 66 ◯ 67

4. MPEG-2 is a lossy compression system. **4** ◯ 68 ◯ 69

5. Codecs specify various forms of compression. **5** ◯ 70 ◯ 71

6. In progressive scanning, four fields make up a complete frame. **6** ◯ 72 ◯ 73

7. In a digital system, the *on* state is usually represented by a 1, the *off* state by a 0. **7** ◯ 74 ◯ 75

8. In interlaced scanning, each scanning cycle from top to bottom generates a frame. **8** ◯ 76 ◯ 77

9. The 720p scanning system produces a complete frame at each scanning cycle. **9** ◯ 78 ◯ 79

10. An analog signal has a higher sampling rate than a digital one. **10** ◯ 80 ◯ 81

11. Similar to digital signals, analog signals can have lossy or lossless states of compression. **11** ◯ 82 ◯ 83

12. In interlaced scanning, two fields make up a complete frame. **12** ◯ 84 ◯ 85

13. A digital signal can be compressed with various codecs. **13** ◯ 86 ◯ 87

14. An analog signal can be compressed with MPEG-2 as well as JPEG codecs. **14** ◯ 88 ◯ 89

15. In progressive scanning, each line is scanned consecutively from top to bottom. **15** ◯ 90 ◯ 91

16. Downloading and streaming are identical digital processes. **16** ◯ 92 ◯ 93

17. LCD and plasma flat-panel displays operate on different principles that show up prominently in picture quality. **17** ◯ 94 ◯ 95

SECTION TOTAL []

PROBLEM-SOLVING APPLICATIONS

1. You are asked to explain why, in most cases, we prefer digital over analog systems in video production. What is your response?

2. Demonstrate the relationship of sampling rate to signal fidelity. What graphics can you use to illustrate the principle of sampling?

3. You are asked to explain the basic difference between interlaced and progressive scanning. What are the advantages and the disadvantages of each system?

4. Why do we have different codecs, and what are their functions?

5. Why do we bother with sampling an analog signal that is already more complete than even the highest sampling rate can provide?

Video Camera

REVIEW OF KEY TERMS

Match each term with its appropriate definition by filling in the corresponding bubble.

1. beam splitter
2. f-stop
3. CCU
4. zoom range
5. CCD

6. focal length
7. aperture
8. chrominance channel
9. fast lens
10. slow lens

11. camcorder
12. camera chain
13. DSLR
14. ENG/EFP camera
15. sensor

A. A specific solid-state imaging device

A ○ ○ ○ ○ ○
 1 2 3 4 5
 ○ ○ ○ ○ ○
 6 7 8 9 10
 ○ ○ ○ ○ ○
 11 12 13 14 15

B. The iris opening of a lens

B ○ ○ ○ ○ ○
 1 2 3 4 5
 ○ ○ ○ ○ ○
 6 7 8 9 10
 ○ ○ ○ ○ ○
 11 12 13 14 15

C. General name for the camera imaging device

C ○ ○ ○ ○ ○
 1 2 3 4 5
 ○ ○ ○ ○ ○
 6 7 8 9 10
 ○ ○ ○ ○ ○
 11 12 13 14 15

PAGE
TOTAL []

1. beam splitter	6. focal length	11. camcorder
2. *f*-stop	7. aperture	12. camera chain
3. CCU	8. chrominance channel	13. DSLR
4. zoom range	9. fast lens	14. ENG/EFP camera
5. CCD	10. slow lens	15. sensor

D. A lens that permits a relatively great amount of light to pass through at its largest aperture setting

D
1 2 3 4 5
6 7 8 9 10
11 12 13 14 15

E. Allows the VO to adjust the color and brightness balance before and during the production

E
1 2 3 4 5
6 7 8 9 10
11 12 13 14 15

F. The degree to which the focal length can be changed from a wide shot to a close-up during a zoom

F
1 2 3 4 5
6 7 8 9 10
11 12 13 14 15

G. Contains the RGB video signals or some combination thereof

G
1 2 3 4 5
6 7 8 9 10
11 12 13 14 15

H. The camera connected with the CCU, power supply, and sync generator

H
1 2 3 4 5
6 7 8 9 10
11 12 13 14 15

P A G E
T O T A L

I. Indicates how much of a scene the lens can see and how magnified the distant object looks

I
○ ○ ○ ○ ○
1 2 3 4 5
○ ○ ○ ○ ○
6 7 8 9 10
○ ○ ○ ○ ○
11 12 13 14 15

J. A lens that permits a relatively small amount of light to pass through at its largest aperture

J
○ ○ ○ ○ ○
1 2 3 4 5
○ ○ ○ ○ ○
6 7 8 9 10
○ ○ ○ ○ ○
11 12 13 14 15

K. Optical device within the camera that divides the white light into three primary colors: red, green, and blue

K
○ ○ ○ ○ ○
1 2 3 4 5
○ ○ ○ ○ ○
6 7 8 9 10
○ ○ ○ ○ ○
11 12 13 14 15

L. The calibration on the lens indicating the aperture (and therefore the amount of light passing through the lens)

L
○ ○ ○ ○ ○
1 2 3 4 5
○ ○ ○ ○ ○
6 7 8 9 10
○ ○ ○ ○ ○
11 12 13 14 15

M. Stands for *digital single-lens reflex*

M
○ ○ ○ ○ ○
1 2 3 4 5
○ ○ ○ ○ ○
6 7 8 9 10
○ ○ ○ ○ ○
11 12 13 14 15

N. A high-end camera that looks like a shoulder-mounted camcorder but has no built-in recording device

N
○ ○ ○ ○ ○
1 2 3 4 5
○ ○ ○ ○ ○
6 7 8 9 10
○ ○ ○ ○ ○
11 12 13 14 15

P A G E
T O T A L []

1. beam splitter	6. focal length	11. camcorder
2. *f*-stop	7. aperture	12. camera chain
3. CCU	8. chrominance channel	13. DSLR
4. zoom range	9. fast lens	14. ENG/EFP camera
5. CCD	10. slow lens	15. sensor

O. A video camera with a built-in recorder

PAGE TOTAL

SECTION TOTAL

REVIEW OF CAMERA FUNCTION AND ELEMENTS

Select the correct answers and fill in the bubbles with the corresponding numbers.

1. The basic parts of the video camera are (16) *pedestal* (17) *lens* (18) *VR* (19) *imaging device* (20) *viewfinder* (21) *tally light*. **(Fill in three bubbles.)**

1
○ 16 ○ 17 ○ 18
○ 19 ○ 20 ○ 21

2. Fill in the bubbles whose numbers correspond with the camera elements shown in the following figure.

a. splits the white light into red, green, and blue light beams

2a
○ 22 ○ 23 ○ 24 ○ 25
○ 26 ○ 27 ○ 28

b. amplifies video signals

2b
○ 22 ○ 23 ○ 24 ○ 25
○ 26 ○ 27 ○ 28

c. reflects light

2c
○ 22 ○ 23 ○ 24 ○ 25
○ 26 ○ 27 ○ 28

d. gathers and transmits the light

2d
○ 22 ○ 23 ○ 24 ○ 25
○ 26 ○ 27 ○ 28

e. converts video signals back into visible screen images

2e
○ 22 ○ 23 ○ 24 ○ 25
○ 26 ○ 27 ○ 28

f. processes video signal

2f
○ 22 ○ 23 ○ 24 ○ 25
○ 26 ○ 27 ○ 28

g. transforms light into electric energy or video signals

2g
○ 22 ○ 23 ○ 24 ○ 25
○ 26 ○ 27 ○ 28

SECTION TOTAL ☐

REVIEW OF LENSES

Select the correct answers and fill in the bubbles with the corresponding numbers.

1. In the diagram below, select the most appropriate *f*-stop number for each of the four apertures (**a** through **d**) and fill in the bubbles with the corresponding number.

a.

(29) *f*/22 (30) *f*/5.6 (31) *f*1.4

1a ○ ○ ○
 29 30 31

b.

(32) *f*/1.4 (33) *f*/2.8 (34) *f*/16

1b ○ ○ ○
 32 33 34

c.

(35) *f*/1.4 (36) *f*/4 (37) *f*/16

1c ○ ○ ○
 35 36 37

d.

(38) *f*/1.4 (39) *f*/8 (40) *f*/22

1d ○ ○ ○
 38 39 40

2. When reaching the maximum digital zoom-in position, the picture gets progressively (41) *sharper* (42) *smaller* (43) *pixelized*.

2 ○ ○ ○
 41 42 43

3. A zoom lens has a (44) *wide* (45) *normal* (46) *narrow* (47) *variable* focal length.

3 ○ ○ ○ ○
 44 45 46 47

4. A short-focal-length lens gives (48) *a wider view than* (49) *a closer view than* (50) *the same vista as* a long-focal-length lens.

4 ○ ○ ○
 48 49 50

SECTION TOTAL []

REVIEW OF THE IMAGING DEVICE, SIGNAL PROCESSING, AND THE CAMERA CHAIN

Select the correct answers and fill in the bubbles with the corresponding numbers.

1. To function properly, camcorders do not need (51) *a power supply* (52) *a video recorder* (53) *an external CCU.*

 1 ○ 51 ○ 52 ○ 53

2. The NTSC signal is a (54) *component* (55) *composite* (56) *complex* signal.

 2 ○ 54 ○ 55 ○ 56

3. The luminance signal is a (57) *composite* (58) *black-and-white* (59) *color* signal.

 3 ○ 57 ○ 58 ○ 59

4. The more pixels a sensor contains, the (60) *more colorful* (61) *brighter* (62) *sharper* the resulting screen image will be.

 4 ○ 60 ○ 61 ○ 62

5. The standard studio camera chain consists of (63) *CCU, CCD, and power supply* (64) *power supply, sync generator, and CCD* (65) *camera head, power supply, sync generator, and CCU.*

 5 ○ 63 ○ 64 ○ 65

6. The recording media that digital cinema cameras cannot use is (66) *videotape* (67) *35mm film* (68) *memory cards.*

 6 ○ 66 ○ 67 ○ 68

7. For image capture, digital cinema uses (69) *high-end HDTV camcorders* (70) *movie cameras with a small TV camera attached* (71) *HDTV camcorders with a film magazine attached.*

 7 ○ 69 ○ 70 ○ 71

8. Studio cameras are normally controlled by (72) *their internal automatic controls* (73) *an external CCU* (74) *an internal CCU.*

 8 ○ 72 ○ 73 ○ 74

9. The beam splitter changes (75) *the incoming light into an electrical signal* (76) *the incoming light into RGB light beams* (77) *the incoming light into color and black-and-white signals.*

 9 ○ 75 ○ 76 ○ 77

10. A CMOS chip is an imaging device that is similar to a (78) *CCU* (79) *DSLR* (80) *CCD.*

 10 ○ 78 ○ 79 ○ 80

SECTION TOTAL []

REVIEW QUIZ

Mark the following statements as true or false by filling in the bubbles in the **T** (for true) or **F** (for false) column.

		T	F
1.	Camcorders can come with or without a video-recording device.	1 ◯ 81	◯ 82
2.	A CCD changes light into electric energy.	2 ◯ 83	◯ 84
3.	The wide-angle position of the zoom lens provides a vista similar to that of a short-focal-length lens.	3 ◯ 85	◯ 86
4.	The sync generator and the power supply fulfill similar functions.	4 ◯ 87	◯ 88
5.	ENG/EFP cameras are the same as ENG/EFP camcorders.	5 ◯ 89	◯ 90
6.	DSLR cameras can capture 1080i video.	6 ◯ 91	◯ 92
7.	A fast lens is judged by its minimum f-stop number.	7 ◯ 93	◯ 94
8.	The ENG/EFP camera contains the major parts of the regular camera chain.	8 ◯ 95	◯ 96
9.	The CCU performs camera setup and control functions but does not help with keeping in focus during a zoom.	9 ◯ 97	◯ 98
10.	The lower the f-stop number, the larger the aperture.	10 ◯ 99	◯ 100
11.	Some ENG/EFP cameras can be connected to an RCU.	11 ◯ 101	◯ 102
12.	*Zoom range* refers to how fast you can zoom in or out.	12 ◯ 103	◯ 104
13.	All video cables must have BNC connectors.	13 ◯ 105	◯ 106
14.	Digital cinema cameras are high-end HDTV camcorders.	14 ◯ 107	◯ 108
15.	A beam splitter divides the incoming white light into red, green, and blue light beams.	15 ◯ 109	◯ 110
16.	A CMOS is a specific type of sensor.	16 ◯ 111	◯ 112
17.	The "K" rating in a digital cinema camera refers to the number of scanning lines.	17 ◯ 113	◯ 114
18.	A 3D camcorder contains two complete camcorders in a single housing.	18 ◯ 115	◯ 116
19.	You can get stereo images by using two separate camcorders side by side: one for the left-eye lens and the other for the right-eye lens.	19 ◯ 117	◯ 118

SECTION TOTAL []

PROBLEM-SOLVING APPLICATIONS

1. The camera operator tells you not to worry about the bright white cap of the dark-skinned golf pro. He says that the automatic iris of the camcorder will take care of the proper exposure. What is your reaction?

2. The director of a multicamera field production is worried that the cameras might not deliver pictures whose colors match when edited together. The TD tells the director that the use of RCUs will greatly help in color matching. Do you agree with the TD?

3. The director tells you that for covering an outdoor sporting event, a lens with a great zoom range is more important than an extremely fast one. Why does the director think so?

4. The director of a multicamera studio show is worried about having one of the cameras pan from a very brightly lighted scene to a very dark one. The TD tells her not to worry because the VO will use the CCU to take care of such problems. Why was the director worried about this pan in the first place? What was the TD talking about, and do you agree with the TD?

5. The director of a remote sporting event asks the TD to change the studio camera lens to one with a higher zoom ratio. How, if at all, would you defend such a request?

6. The producer is amazed that the DP of a digital cinema shoot prefers to work with a black-and-white viewfinder. How, if at all, would you defend the DP's choice?

7. A salesperson of a well-known lens manufacturer tell you that the quality of the lens is almost as important for high-resolution images as the image sensor. Would you "buy" her statement? Be specific.

8. What are the major advantages and disadvantages of using a DSLR camera as a camcorder?

Operating the Camera

REVIEW OF KEY TERMS

Match each term with its appropriate definition by filling in the corresponding bubble.

1. shutter speed
2. white balance
3. tongue
4. tilt
5. mounting head

6. cant
7. truck
8. crane
9. calibrate the zoom lens
10. jib arm

11. dolly
12. pedestal
13. arc
14. pan

A. A device that connects the camera to its support

A ① ② ③ ④ ⑤
 1 2 3 4 5
 ⑥ ⑦ ⑧ ⑨ ⑩
 6 7 8 9 10
 ⑪ ⑫ ⑬ ⑭
 11 12 13 14

B. To move the camera in a slightly curved dolly or truck

B ① ② ③ ④ ⑤
 1 2 3 4 5
 ⑥ ⑦ ⑧ ⑨ ⑩
 6 7 8 9 10
 ⑪ ⑫ ⑬ ⑭
 11 12 13 14

C. Small crane that can be operated by the camera operator

C ① ② ③ ④ ⑤
 1 2 3 4 5
 ⑥ ⑦ ⑧ ⑨ ⑩
 6 7 8 9 10
 ⑪ ⑫ ⑬ ⑭
 11 12 13 14

P A G E
T O T A L []

1. shutter speed	6. cant	11. dolly
2. white balance	7. truck	12. pedestal
3. tongue	8. crane	13. arc
4. tilt	9. calibrate the zoom lens	14. pan
5. mounting head	10. jib arm	

D. To move the boom with the camera from left to right or from right to left

D
○ ○ ○ ○ ○
1 2 3 4 5
○ ○ ○ ○ ○
6 7 8 9 10
○ ○ ○ ○
11 12 13 14

E. Horizontal turning of the camera

E
○ ○ ○ ○ ○
1 2 3 4 5
○ ○ ○ ○ ○
6 7 8 9 10
○ ○ ○ ○
11 12 13 14

F. The adjustment of the color channels in the camera to produce a white color in lighting of various color temperatures

F
○ ○ ○ ○ ○
1 2 3 4 5
○ ○ ○ ○ ○
6 7 8 9 10
○ ○ ○ ○
11 12 13 14

G. To point the camera up or down

G
○ ○ ○ ○ ○
1 2 3 4 5
○ ○ ○ ○ ○
6 7 8 9 10
○ ○ ○ ○
11 12 13 14

H. To preset a zoom lens to keep it in focus throughout the zoom

H
○ ○ ○ ○ ○
1 2 3 4 5
○ ○ ○ ○ ○
6 7 8 9 10
○ ○ ○ ○
11 12 13 14

P A G E
T O T A L

I. To move the camera up or down with a studio camera mount

I
○ ○ ○ ○ ○
1　2　3　4　5
○ ○ ○ ○ ○
6　7　8　9　10
○ ○ ○ ○
11　12　13　14

J. To move the camera toward or away from the object

J
○ ○ ○ ○ ○
1　2　3　4　5
○ ○ ○ ○ ○
6　7　8　9　10
○ ○ ○ ○
11　12　13　14

K. To move the camera laterally by means of a mobile camera mount

K
○ ○ ○ ○ ○
1　2　3　4　5
○ ○ ○ ○ ○
6　7　8　9　10
○ ○ ○ ○
11　12　13　14

L. The faster it is set, the less blurred a moving object will be

L
○ ○ ○ ○ ○
1　2　3　4　5
○ ○ ○ ○ ○
6　7　8　9　10
○ ○ ○ ○
11　12　13　14

M. To move the boom of the camera crane up or down

M
○ ○ ○ ○ ○
1　2　3　4　5
○ ○ ○ ○ ○
6　7　8　9　10
○ ○ ○ ○
11　12　13　14

N. Tilting the camera sideways

N
○ ○ ○ ○ ○
1　2　3　4　5
○ ○ ○ ○ ○
6　7　8　9　10
○ ○ ○ ○
11　12　13　14

PAGE
TOTAL

SECTION
TOTAL

REVIEW OF CAMERA MOVEMENTS AND MOUNTS

Select the correct answers and fill in the bubbles with the corresponding numbers.

1. Fill in the bubbles whose numbers correspond with the camera movements indicated in the following figure.

a. dolly

b. truck

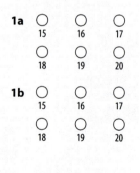

1a ○ ○ ○
 15 16 17

 ○ ○ ○
 18 19 20

1b ○ ○ ○
 15 16 17

 ○ ○ ○
 18 19 20

PAGE
TOTAL

c. tilt

1c ○ ○ ○
15 16 17
○ ○ ○
18 19 20

d. pan

1d ○ ○ ○
15 16 17
○ ○ ○
18 19 20

e. pedestal

1e ○ ○ ○
15 16 17
○ ○ ○
18 19 20

f. arc

1f ○ ○ ○
15 16 17
○ ○ ○
18 19 20

2. A spreader (21) *keeps the tripod legs from spreading too far* (22) *helps spread the tripod legs as much as possible* (23) *maximizes the spread of the tripod legs.*

2 ○ ○ ○
21 22 23

3. The quick-release plate (24) *facilitates the mounting of a camera on the mounting head* (25) *secures the dolly base to the tripod legs.*

3 ○ ○
24 25

4. A mounting head's drag control is important (26) *only for heavy studio cameras* (27) *only for lightweight camcorders* (28) *for both studio cameras and camcorders.*

4 ○ ○ ○
26 27 28

5. For all normal camera moves, the studio pedestal is usually set for (29) *parallel* (30) *tricycle* (31) *freewheeling* steering.

5 ○ ○ ○
29 30 31

6. To minimize the wiggles of a handheld or shoulder-mounted camcorder, you should have the camera lens (32) *zoomed out all the way (wide-angle position)* (33) *zoomed in all the way (narrow-angle position)* (34) *zoomed in halfway (normal-focal-length position).*

6 ○ ○ ○
32 33 34

```
PAGE
TOTAL   [        ]

SECTION
TOTAL   [        ]
```

REVIEW OF OPERATIONAL FEATURES

Select the correct answers and fill in the bubbles with the corresponding numbers.

1. When panning with a shoulder-mounted camcorder, you should point your knees in the direction of the (35) *beginning of the pan* (36) *middle of the pan* (37) *end of the pan.*

 1 ◯ ◯ ◯
 35 36 37

2. The focus-assist feature facilitates (38) *auto-focus* (39) *manual focus* (40) *manual and auto-focus.*

 2 ◯ ◯ ◯
 38 39 40

3. When a fast-moving object blurs, you need to (41) *increase the shutter speed* (42) *decrease the shutter speed* (43) *open the aperture.*

 3 ◯ ◯ ◯
 41 42 43

4. To cant a shoulder-mounted camcorder, you must tilt it (44) *down* (45) *sideways* (46) *up.*

 4 ◯ ◯ ◯
 44 45 46

5. When white-balancing an ENG/EFP camera for covering a school board meeting in the school's multipurpose room, you should white-balance the camera (47) *in the hallway before entering the room* (48) *with a special white-balancing light* (49) *in the light that actually illuminates the area where the school board members sit.*

 5 ◯ ◯ ◯
 47 48 49

6. It is easiest to keep the image in focus when you are zoomed (50) *all the way in* (51) *halfway in* (52) *all the way out.*

 6 ◯ ◯ ◯
 50 51 52

7. Calibrating, or presetting, the zoom lens means (53) *adjusting the zoom lens so that it stays in focus throughout the zoom* (54) *setting the proper f-stop* (55) *adjusting the zoom range.*

 7 ◯ ◯ ◯
 53 54 55

8. Proper calibration of the zoom lens requires that you (56) *zoom in* (57) *zoom out* and focus on the target object (58) *closest to* (59) *farthest from* the camera. **(Fill in two bubbles.)**

 8 ◯ ◯ ◯ ◯
 56 57 58 59

SECTION TOTAL []

REVIEW QUIZ

*Mark the following statements as true or false by filling in the bubbles in the **T** (for true) or*
***F** (for false) column.*

		T	F
1.	Dolly and truck movements show up as similar movements on the screen.	**1** ○ 60	○ 61
2.	Calibrating the zoom lens is necessary for ENG/EFP cameras as well as for studio cameras.	**2** ○ 62	○ 63
3.	The jib arm and the camera crane can make the camera move in similar ways.	**3** ○ 64	○ 65
4.	The depth of field depends on the focal length of the lens, the lens aperture, and the distance from camera to object.	**4** ○ 66	○ 67
5.	To ensure optimal color fidelity and continuity, you need to white-balance every time the camera is moved from one lighting environment to the next.	**5** ○ 68	○ 69
6.	Zooming all the way in will minimize camera wobbles.	**6** ○ 70	○ 71
7.	The best way to lock the camera mounting head when leaving the camera unattended is to tighten the drag control.	**7** ○ 72	○ 73
8.	The automatic focus on a camcorder guarantees staying in focus at all times.	**8** ○ 74	○ 75
9.	HDTV cameras are easier to focus than standard digital camcorders.	**9** ○ 76	○ 77
10.	To tilt up means to raise the camera pedestal.	**10** ○ 78	○ 79
11.	With a jib arm, you can boom, tongue, and pan the camera in a single motion.	**11** ○ 80	○ 81
12.	The quick-release plate ensures the quick attachment and removal of the mounting head to and from the tripod.	**12** ○ 82	○ 83
13.	Generally, tight close-ups have a shallow depth of field.	**13** ○ 84	○ 85
14.	To avoid blurring a fast-moving object, you need to use a high shutter speed.	**14** ○ 86	○ 87
15.	To calibrate a zoom lens, you must first zoom in and focus on the target object.	**15** ○ 88	○ 89

**SECTION
TOTAL** []

PROBLEM-SOLVING APPLICATIONS

1. Locate the tilt and pan drag and lock mechanisms of the mounting head. Adjust them so that you can pan and tilt the camera as smoothly as possible.

2. Place three chairs along the z-axis about 9 feet apart. Zoom in to an ECU on the first chair. It will probably be out of focus at the end of the zoom. Now bring the picture into focus. When zooming out, the picture will remain in focus. Without touching the focus, now zoom in on the last chair. Again, the picture will probably get out of focus when reaching the ECU of the last chair. Now focus on the last chair and zoom back out. Without adjusting the focus, zoom in on the second chair, zoom back, and then zoom in again on the last chair. Will the second as well as the last chair remain in focus during the zoom-in? If so, why? If not, why not?

3. With your knees pointing in the direction of the start of the pan, pan the camera slowly and smoothly about 100 degrees. Now repeat the same pan with your knees preset as much as possible in the direction of the end point of the pan. Which position makes for a smoother pan? Why?

4. With the automatic white balance turned off, video-record for a few seconds a white object (such as a small white card) outdoors, then repeat the same shot with indoor lighting (such as with your reading lamp shining on it) and then under fluorescent lights. Compare the various color tints of the "white" card. Repeat the same procedure but with the automatic white balance turned on or by white-balancing for each of the illuminations. Now do the colors of the white object look the same in each shot? Why?

5. With a handheld or shoulder-mounted camcorder, follow a friend from behind and video-record him or her while walking along the z-axis. Now do the same while walking backward and having your friend face the camera during the video-recording. Which version made it easier for you to keep the camera steady? Why?

6. You happen to overhear one of the camera operators of a multicamera production brag about never using the locking mechanism of the mounting head when leaving the camera unattended; she says she uses a tighter pan-and-tilt adjustment instead. She says that this will add a minute to her coffee break. What is your reaction? Be specific.

Looking through the Viewfinder

REVIEW OF KEY TERMS

Match each term with its appropriate definition by filling in the corresponding bubble.

1. O/S
2. headroom
3. noseroom
4. depth of field

5. POC
6. vector
7. z-axis
8. MS

9. LS
10. aspect ratio
11. psychological closure
12. field of view

A. The space left between the top of the head and the upper screen edge

A ◯ ⊙ ◯ ◯
 1 2 3 4
◯ ◯ ◯ ◯
5 6 7 8
◯ ◯ ◯ ◯
9 10 11 12

B. Object seen from a midrange distance

B ◯ ◯ ◯ ◯
 1 2 3 4
◯ ◯ ◯ ⊙
5 6 7 8
◯ ◯ ◯ ◯
9 10 11 12

C. The relationship of screen width to screen height

C ◯ ◯ ◯ ◯
 1 2 3 4
◯ ◯ ◯ ◯
5 6 7 8
◯ ⊙ ◯ ◯
9 10 11 12

```
P A G E
T O T A L   [         ]
```

1. O/S	5. POC	9. LS	
2. headroom	6. vector	10. aspect ratio	
3. noseroom	7. z-axis	11. psychological closure	
4. depth of field	8. MS	12. field of view	

D. The space left in front of a person looking toward the edge of the screen

D
○ ○ ⊙ ○
1 2 3 4
○ ○ ○ ○
5 6 7 8
○ ○ ○ ○
9 10 11 12

E. The area in which all objects, located at different distances from the camera, are in focus

E
○ ○ ○ ⊙
1 2 3 4
○ ○ ○ ○
5 6 7 8
○ ○ ○ ○
9 10 11 12

F. The point where the z-axis of the right-eye camera intersects with the z-axis of the left-eye camera

F
○ ○ ○ ○
1 2 3 4
⊙ ○ ○ ○
5 6 7 8
○ ○ ○ ○
9 10 11 12

G. Camera looks over the camera-near person's shoulder

G
⊙ ○ ○ ○
1 2 3 4
○ ○ ○ ○
5 6 7 8
○ ○ ○ ○
9 10 11 12

H. A directional screen force

H
○ ○ ○ ○
1 2 3 4
○ ⊙ ○ ○
5 6 7 8
○ ○ ○ ○
9 10 11 12

P A G E
T O T A L []

I. Object seen from far away or framed very loosely

I
○ ○ ○ ○
1 2 3 4
○ ○ ○ ○
5 6 7 8
⊙ ○ ○ ○
9 10 11 12

J. The portion of a scene visible through a particular lens; its vista

J
○ ○ ○ ○
1 2 3 4
○ ○ ○ ○
5 6 7 8
○ ○ ○ ⊙
9 10 11 12

K. Mentally filling in missing visual information that will lead to a complete and stable configuration

K
○ ○ ○ ○
1 2 3 4
○ ○ ○ ○
5 6 7 8
○ ○ ⊙ ○
9 10 11 12

L. Indicates screen depth; extends from camera lens to horizon and in 3D also from screen to viewer

L
○ ○ ○ ○
1 2 3 4
○ ○ ⊙ ○
5 6 7 8
○ ○ ○ ○
9 10 11 12

P A G E
T O T A L []

SECTION
TOTAL []

REVIEW OF FRAMING A SHOT AND PICTURE COMPOSITION

Select the correct answers and fill in the bubbles with the corresponding numbers.

1. The aspect ratio of the HDTV screen is (13) *4 × 3* (14) *16 × 9* (15) *4 × 9.*

1 ◯ ⊙ ◯
 13 14 15

2. Using the following set of numbered images, fill in the corresponding bubble for each of the fields of view or other shot designations listed below.

 16 17 18

 19 20 21

 22 23 24

a. LS (long shot)

2a ◯ ⊙ ◯ ◯ ◯
 16 17 18 19 20
 ◯ ◯ ◯ ◯
 21 22 23 24

b. MS (medium shot)

2b ◯ ◯ ◯ ◯ ◯
 16 17 18 19 20
 ◯ ◯ ◯ ⊙
 21 22 23 24

PAGE TOTAL

c. three-shot

2c ⭕ ⭕ ⭕ ⭕ ⭕
 16 17 18 19 20

⊙ ⭕ ⭕ ⭕
21 22 23 24

d. bust shot

2d ⭕ ⭕ ⭕ ⭕ ⭕
 16 17 18 19 20

⭕ ⊙ ⭕ ⭕
21 22 23 24

e. CU (close-up)

2e ⭕ ⭕ ⭕ ⊙ ⭕
 16 17 18 19 20

⭕ ⭕ ⭕ ⭕
21 22 23 24

f. knee shot

2f ⊙ ⭕ ⭕ ⭕ ⭕
 16 17 18 19 20

⭕ ⭕ ⭕ ⭕
21 22 23 24

g. ECU (extreme close-up)

2g ⭕ ⭕ ⊙ ⭕ ⭕
 16 17 18 19 20

⭕ ⭕ ⭕ ⭕
21 22 23 24

h. over-the-shoulder shot (O/S)

2h ⭕ ⭕ ⭕ ⭕ ⊙
 16 17 18 19 20

⭕ ⭕ ⭕ ⭕
21 22 23 24

i. ELS (extreme long shot)

2i ⭕ ⭕ ⭕ ⭕ ⭕
 16 17 18 19 20

⭕ ⭕ ⊙ ⭕
21 22 23 24

P A G E
T O T A L

CHAPTER 6 *LOOKING THROUGH THE VIEWFINDER*

3. Evaluate the standard framing of shots in the next eight figures by filling in the bubbles with the corresponding numbers.

Edward Aiona

a. The framing of this shot is (25) *acceptable* (26) *unacceptable* because the tilted horizon (27) *makes the shot more dynamic* (28) *is inappropriate in this context.* *(Fill in two bubbles.)*

3a ◯ ◉ ◯ ◉
 25 26 27 28

Edward Aiona

b. This CU is (29) *acceptable* (30) *unacceptable* because it has (31) *no headroom* (32) *too much headroom* (33) *no noseroom* (34) *sufficient clues for closure in off-screen space.* *(Fill in two bubbles.)*

3b ◯ ◉
 29 30

◉ ◯ ◯ ◯
31 32 33 34

Edward Aiona

c. This shot is intended to emphasize the dynamic nature of big city buildings. Its framing is (35) *acceptable* (36) *unacceptable.*

3c ◉ ◯
 35 36

PAGE TOTAL []

Herbert Zettl

d. This shot makes (37) *good* (38) *poor* use of screen depth. If depth improvement is needed, you should (39) *add foreground objects* (40) *take a tighter shot of the flags.* *(Fill in two bubbles.)*

3d ◯ ◯ ◯ ◯
 37 38 39 40

Edward Aiona

e. The framing of this shot is (41) *acceptable* (42) *unacceptable* because the tilted horizon (43) *makes the shot more dynamic* (44) *is inappropriate in this context.* *(Fill in two bubbles.)*

3e ◯ ◯ ◯ ◯
 41 42 43 44

Edward Aiona

f. This shot is (45) *acceptable* (46) *unacceptable* because it has (47) *too much noseroom* (48) *too little noseroom* (49) *too much headroom* (50) *too much leadroom.* *(Fill in two bubbles.)*

3f ◯ ◯
 45 46

◯ ◯ ◯ ◯
47 48 49 50

P A G E
T O T A L []

Edward Aiona

g. This over-the-shoulder shot is (51) *acceptable* (52) *unacceptable.*

Edward Aiona

h. This ECU is (53) *acceptable* (54) *unacceptable* because it has (55) *no headroom* (56) *no leadroom* (57) *sufficient clues for closure in off-screen space* (58) *insufficient clues for closure in off-screen space.* (**Fill in two bubbles.**)

REVIEW OF VECTORS AND PSYCHOLOGICAL CLOSURE

1. Evaluate the following two figures by filling in the bubbles with the corresponding numbers.

Edward Aiona

a. The framing of this shot is (59) *acceptable* (60) *unacceptable* because it (61) *leads us to undesirable closure within the frame* (62) *leads us to undesirable closure in off-screen space* (63) *leads us to desirable closure in off-screen space* (64) *prevents closure.* **(Fill in two bubbles.)**

1a ◯ ◌
 59 60
◯ ◯ ◯ ◯
61 62 63 64

Edward Aiona

b. The framing of this shot is (65) *acceptable* (66) *unacceptable* because it (67) *leads us to undesirable closure within the frame* (68) *leads us to undesirable closure in off-screen space* (69) *leads us to desirable closure in off-screen space* (70) *prevents closure.* **(Fill in two bubbles.)**

1b ◯ ◯
 65 66
◯ ◯ ◌ ◯
67 68 69 70

PAGE
TOTAL []

2. Identify the specific vectors displayed in the following three figures by filling in the bubbles with the corresponding numbers.

Edward Aiona

a. This picture shows prominent (71) *graphic* (72) *index* (73) *motion* vectors.

2a ⊙ 71 ◯ 72 ◯ 73

Herbert Zettl

b. This picture shows (74) *graphic* (75) *index* (76) *motion* vectors.

2b ◯ 74 ◯ 75 ◯ 76

Herbert Zettl

c. This picture shows a prominent (77) *graphic* (78) *index* (79) *motion* vector.

2c ◯ 77 ◯ 78 ⊙ 79

PAGE TOTAL

SECTION TOTAL

REVIEW OF LENSES, DEPTH OF FIELD, AND Z-AXIS MANIPULATION

Select the correct answers and fill in the bubbles with the corresponding numbers.

1. The two 3D camera setups below show a narrow and wider distance between the parallel left-eye and right-eye lenses. Fill in the bubble whose number corresponds with the setup that will produce the longer virtual z-axis from screen to viewer.

1 ○ ⊙
 80 81

80 81

2. The two figures below show different points of convergence of the stereo camera setup. Fill in the bubble whose number corresponds with the convergence point that will place both objects (A and B) in front of the screen.

2 ○ ○
 82 83

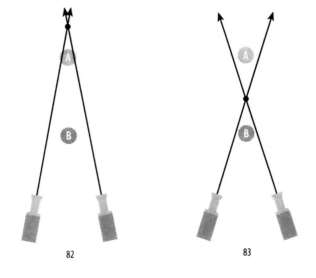

82 83

PAGE
TOTAL []

3. A narrow-angle lens position gives you a relatively (84) *shallow* (85) *wide* (86) *great* depth of field.

3 ◯ ◯ ◯
 84 85 86

4. A wide-angle lens position gives you a relatively (87) *shallow* (88) *wide* (89) *great* depth of field.

4 ◯ ◯ ◯
 87 88 89

5. The figure below shows the camera zoomed in all the way for a telephoto view and focused on object A. Object B will probably be (90) *in focus* (91) *out of focus.* The depth of field is therefore (92) *great* (93) *shallow.* **(Fill in two bubbles.)**

5 ◯ ◯ ◯ ◯
 90 91 92 93

6. The figure below shows the camera zoomed out all the way for a wide-angle view and focused on object A. Object B will probably be (94) *in focus* (95) *out of focus.* The depth of field is therefore (96) *great* (97) *shallow.* **(Fill in two bubbles.)**

6 ◯ ◯ ◯ ◯
 94 95 96 97

7. The area in which all objects, although located at different distances from the camera, are in focus is called (98) *depth of focus* (99) *field of view* (100) *depth of field.*

7 ◯ ◯ ◯
 98 99 100

PAGE TOTAL []

W-60

8. The screen image below displays a (101) *great* (102) *shallow* depth of field.

8 ◯ 101 ◉ 102

Edward Aiona

9. The screen image below shows that the camera's zoom lens was in a (103) *wide-angle* (104) *narrow-angle* position.

9 ◉ 103 ◯ 104

Herbert Zettl

10. The preview monitors for cameras 1, 2, and 3 display the following images. Assuming that all three cameras are positioned right next to one another, what is the approximate zoom position for each? Choose among (105) *wide angle (short focal length)* (106) *normal (medium focal length)* and (107) *narrow angle (long focal length)*.

10a ◯ 105 ◯ 106 ◯ 107
10b ◯ 105 ◉ 106 ◯ 107
10c ◉ 105 ◯ 106 ◯ 107

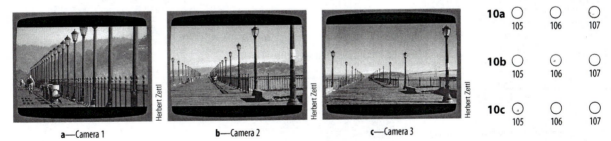

a—Camera 1 Herbert Zettl b—Camera 2 Herbert Zettl c—Camera 3 Herbert Zettl

PAGE TOTAL []

SECTION TOTAL []

REVIEW QUIZ

Mark the following statements as true or false by filling in the bubbles in the **T** (for true) or **F** (for false) column.

		T	F
1.	An effective close-up should provide visual clues for closure in off-screen space.	1 ⊙ 108	○ 109
2.	Leadroom and noseroom fulfill similar framing (compositional) functions.	2 ○ 110	○ 111
3.	You should always try to achieve psychological closure within the TV screen area.	3 ○ 112	○ 113
4.	There is no aesthetic difference between a zoom and a dolly.	4 ○ 114	⊙ 115
5.	Wide-angle zoom positions slow down perceived z-axis speed.	5 ⊙ 116	○ 117
6.	Psychological closure always ensures good composition.	6 ○ 118	⊙ 119
7.	Wide vistas are easier to frame in the 16 × 9 aspect ratio than in the 4 × 3 aspect ratio.	7 ⊙ 120	○ 121
8.	In stereo 3D videography, the point of convergence marks the plane of the screen.	8 ⊙ 122	○ 123
9.	In general, video is more of a close-up than a long-shot medium.	9 ⊙ 124	○ 125
10.	When following lateral motion, you should keep as little space as possible between the object and the screen edge toward which the object is moving.	10 ○ 126	⊙ 127
11.	A tilted horizon line can make the composition less stable and more dynamic.	11 ⊙ 128	○ 129
12.	The focal length of the lens has little influence on how we perceive z-axis blocking.	12 ○ 130	⊙ 131
13.	The aperture of a lens influences the depth of field.	13 ⊙ 132	○ 133
14.	Z-axis blocking is especially advantageous for the small screen.	14 ⊙ 134	○ 135
15.	The focal length of lenses has considerable influence on the depth of field.	15 ⊙ 136	○ 137
16.	In a stereo camera setup, the distance between the parallel camera lenses has no influence on how we perceive the from-screen-to-viewer z-axis.	16 ○ 138	⊙ 139
17.	Close-ups normally have a shallow depth of field.	17 ⊙ 140	○ 141

SECTION TOTAL ☐

PROBLEM-SOLVING APPLICATIONS

1. With your camcorder in the wide-angle zoom lens position, walk toward an object. Go back to your starting point and this time zoom in on the object. When playing back the two scenes, can you tell which was the dolly and which was the zoom? How?

2. When watching television or a movie, try to figure out what lenses (zoom lens positions) were used for some of the shots. For example, when you see someone running toward the camera yet seemingly not getting closer, what lens was used? Or when you see the happy couple approach the dinner table through the out-of-focus flowers and candles in the foreground, what lens was probably used? Such observations will help you become more aware of focal lengths and their effects. Compare your notes with those of others watching the same program or movie.

3. Your documentary is to show the congestion and the lack of breathing space between the units in a new suburban housing development. When aiming your camera along the street, what zoom lens position would you use? Why?

4. The director wants the foreground object in focus but the background out of focus. How can you accomplish this request?

5. The director tells you, the camera operator, to change from a cross-shot to an over-the-shoulder shot. What does the director mean? How can you accomplish such a shot change?

6. Zoom all the way out with your camcorder and focus on an object about 4 to 6 feet away from you. Look at the background objects (about 20 feet away from you). Are they visible? Do they appear in fairly sharp focus or are they blurred? Next make the same observations by backing up a little with your camera and zooming in all the way on the camera-near object. Is the background still clearly visible? Relate your observations to depth of field.

7. When your two HDTV studio cameras focus on the interview set, you discover that some of the background flaws become clearly visible and distracting. What can you do at the last minute before the scheduled video recording?

8. When simulating a crowd blocked along the z-axis, should you use a wide-angle or a narrow-angle zoom lens position? Why?

PART

III

Image Creation:
Sound, Light, Graphics,
and Effects

Audio and Sound Control

REVIEW OF KEY TERMS

Match each term with its appropriate definition by filling in the corresponding bubble.

1. fader
2. pop filter
3. unidirectional
4. lavalier
5. VU meter
6. hypercardioid

7. XLR
8. sweetening
9. condenser microphone
10. polar pattern
11. cardioid

12. pickup pattern
13. ribbon microphone
14. dynamic microphone
15. windscreen
16. omnidirectional

A. A professional three-wire connector for audio cables

A ○ ○ ○ ○
 1 2 3 4
 ○ ○ ○ ○
 5 6 7 8
 ○ ○ ○ ○
 9 10 11 12
 ○ ○ ○ ○
 13 14 15 16

B. Acoustic foam rubber that is put over the microphone to cut down wind noise in outdoor use

B ○ ○ ○ ○
 1 2 3 4
 ○ ○ ○ ○
 5 6 7 8
 ○ ○ ○ ○
 9 10 11 12
 ○ ○ ○ ○
 13 14 15 16

PAGE
TOTAL []

1. fader	7. XLR	12. pickup pattern
2. pop filter	8. sweetening	13. ribbon microphone
3. unidirectional	9. condenser microphone	14. dynamic microphone
4. lavalier	10. polar pattern	15. windscreen
5. VU meter	11. cardioid	16. omnidirectional
6. hypercardioid		

C. A narrow, highly directional pickup pattern

C
1 2 3 4
5 6 7 8
9 10 11 12
13 14 15 16

D. A small microphone that is clipped onto clothing

D
1 2 3 4
5 6 7 8
9 10 11 12
13 14 15 16

E. A heart-shaped pickup pattern

E
1 2 3 4
5 6 7 8
9 10 11 12
13 14 15 16

F. A microphone that can mainly hear sounds that come from the front

F
1 2 3 4
5 6 7 8
9 10 11 12
13 14 15 16

P A G E
T O T A L

G. A microphone that can hear equally well from all directions

G
○ ○ ○ ○
1 2 3 4
○ ○ ○ ○
5 6 7 8
○ ○ ○ ○
9 10 11 12
○ ○ ○ ○
13 14 15 16

H. The two-dimensional representation of the pickup pattern

H
○ ○ ○ ○
1 2 3 4
○ ○ ○ ○
5 6 7 8
○ ○ ○ ○
9 10 11 12
○ ○ ○ ○
13 14 15 16

I. A relatively rugged microphone, good for outdoor use

I
○ ○ ○ ○
1 2 3 4
○ ○ ○ ○
5 6 7 8
○ ○ ○ ○
9 10 11 12
○ ○ ○ ○
13 14 15 16

J. High-quality, highly sensitive microphone for critical sound pickup; produces warm sound

J
○ ○ ○ ○
1 2 3 4
○ ○ ○ ○
5 6 7 8
○ ○ ○ ○
9 10 11 12
○ ○ ○ ○
13 14 15 16

K. The territory around the microphone within which the mic can hear well

K
○ ○ ○ ○
1 2 3 4
○ ○ ○ ○
5 6 7 8
○ ○ ○ ○
9 10 11 12
○ ○ ○ ○
13 14 15 16

P A G E
T O T A L

1. fader	7. XLR	12. pickup pattern
2. pop filter	8. sweetening	13. ribbon microphone
3. unidirectional	9. condenser microphone	14. dynamic microphone
4. lavalier	10. polar pattern	15. windscreen
5. VU meter	11. cardioid	16. omnidirectional
6. hypercardioid		

L. A sliding volume control

L
○ ○ ○ ○
1　2　3　4
○ ○ ○ ○
5　6　7　8
○ ○ ○ ○
9　10　11　12
○ ○ ○ ○
13　14　15　16

M. Wire-mesh screen attached to the front of a mic to reduce sudden air blasts

M
○ ○ ○ ○
1　2　3　4
○ ○ ○ ○
5　6　7　8
○ ○ ○ ○
9　10　11　12
○ ○ ○ ○
13　14　15　16

N. High-quality microphone with a battery power supply

N
○ ○ ○ ○
1　2　3　4
○ ○ ○ ○
5　6　7　8
○ ○ ○ ○
9　10　11　12
○ ○ ○ ○
13　14　15　16

O. Measures volume units, the relative loudness of amplified sound

O
○ ○ ○ ○
1　2　3　4
○ ○ ○ ○
5　6　7　8
○ ○ ○ ○
9　10　11　12
○ ○ ○ ○
13　14　15　16

PAGE
TOTAL _____

P. Manipulating recorded sound in postproduction

P ◯ ◯ ◯ ◯
 1 2 3 4

◯ ◯ ◯ ◯
5 6 7 8

◯ ◯ ◯ ◯
9 10 11 12

◯ ◯ ◯ ◯
13 14 15 16

PAGE TOTAL

SECTION TOTAL

REVIEW OF SOUND-GENERATING ELEMENTS AND SOUND PICKUP

Select the correct answers and fill in the bubbles with the corresponding numbers.

1. Fill in the bubbles whose numbers correspond with the polar patterns in the following figure.

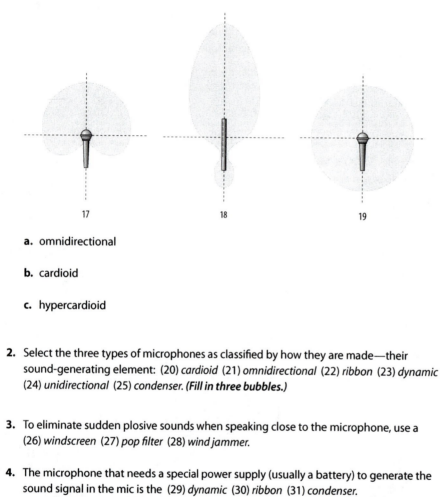

17 18 19

a. omnidirectional

b. cardioid

c. hypercardioid

	17	18	19
1a	○	○	○
1b	○	○	○
1c	○	○	○

2. Select the three types of microphones as classified by how they are made—their sound-generating element: (20) *cardioid* (21) *omnidirectional* (22) *ribbon* (23) *dynamic* (24) *unidirectional* (25) *condenser*. **(Fill in three bubbles.)**

2 ○ 20 ○ 21 ○ 22
 ○ 23 ○ 24 ○ 25

3. To eliminate sudden plosive sounds when speaking close to the microphone, use a (26) *windscreen* (27) *pop filter* (28) *wind jammer*.

3 ○ 26 ○ 27 ○ 28

4. The microphone that needs a special power supply (usually a battery) to generate the sound signal in the mic is the (29) *dynamic* (30) *ribbon* (31) *condenser*.

4 ○ 29 ○ 30 ○ 31

5. A shotgun mic has a pickup pattern that is (32) *omnidirectional* (33) *unidirectional (hypercardioid)* (34) *nondirectional*.

5 ○ 32 ○ 33 ○ 34

6. The most rugged microphones that work well outdoors are (35) *condenser* (36) *ribbon* (37) *dynamic*.

6 ○ 35 ○ 36 ○ 37

SECTION TOTAL []

REVIEW OF MICROPHONE USE

Select the correct answers and fill in the bubbles with the corresponding numbers.

1. In noisy surroundings, the field reporter must speak (38) *across* (39) *into* (40) *at a right angle to* the hand mic.

 1 ○ 38 ○ 39 ○ 40

2. The high-quality hand microphone normally used by singers is a (41) *dynamic* (42) *supercardioid* (43) *condenser* microphone.

 2 ○ 41 ○ 42 ○ 43

3. The hand microphones used in ENG normally have (44) *an omnidirectional* (45) *a bidirectional* (46) *a hyper- or supercardioid* pickup pattern.

 3 ○ 44 ○ 45 ○ 46

4. Of the three mics listed, the most useful mic for a singer in a band is the (47) *boom* (48) *stand* (49) *lavalier* mic.

 4 ○ 47 ○ 48 ○ 49

5. Boom microphones normally have (50) *an omnidirectional* (51) *a cardioid* (52) *a hyper- or supercardioid* pickup pattern.

 5 ○ 50 ○ 51 ○ 52

6. You are to set up microphones for a six-member panel discussion. All participants sit in a row at a long table. Normally, you would use (53) *desk* (54) *hand* (55) *boom* mics for this production.

 6 ○ 53 ○ 54 ○ 55

7. When interviewing a swimmer after a race, the most flexible microphone is the (56) *boom* (57) *hand* (58) *lavalier* mic.

 7 ○ 56 ○ 57 ○ 58

8. A single news anchor usually uses a (59) *lavalier* (60) *hand* (61) *boom* mic.

 8 ○ 59 ○ 60 ○ 61

9. When using a shotgun mic outdoors, you should cover it with a (62) *windscreen* (63) *styrofoam casing* (64) *windsock*. (**Multiple answers are possible.**)

 9 ○ 62 ○ 63 ○ 64

10. The most appropriate mics for the voice pickup of a four-person studio news team (two anchors, a sportscaster, and a weathercaster) are (65) *boom mics* (66) *desk mics* (67) *lavaliers* (68) *a hand mic for the weathercaster and lavaliers for the seated talent.*

 10 ○ 65 ○ 66 ○ 67 ○ 68

11. When using a pencil mic on a fishpole, you can pick up the sound (69) *only from above* (70) *only from below* (71) *from above or below* the source.

 11 ○ 69 ○ 70 ○ 71

SECTION TOTAL []

REVIEW OF SOUND CONTROL

Select the correct answers and fill in the bubbles with the corresponding numbers.

1. The place that marks the beginning of the "overload" zone is (72) *–5 VU* (73) *–2 VU* (74) *0 VU*.

2. For digital recording, the test tone should be (75) *0 VU* (76) *below 0 VU* (77) *above 0 VU*.

3. Normally, the test tone at the beginning of a videotape leader should be (78) *–1 VU* (79) *+1 VU* (80) *0 VU*.

4. Overloading the volume of the incoming sound signal will result in (81) *distorted sound* (82) *feedback* (83) *damage to the VU meter*.

5. The variety of quality controls on an audio console is (84) *greater than* (85) *the same as* (86) *less than* the quality controls on an audio mixer.

6. Most professional mic cables use (87) *RCA phono* (88) *mini plug* (89) *XLR* connectors.

7. When recording digital audio, the VU meter (90) *can* (91) *can occasionally* (92) *should never* spill into the overload zone.

8. When plugging a mic into a camcorder or mixer, the mic cable must be plugged into the (93) *line-level* (94) *remote* (95) *mic-level* jack.

1 ◯ 72 ◯ 73 ◯ 74

2 ◯ 75 ◯ 76 ◯ 77

3 ◯ 78 ◯ 79 ◯ 80

4 ◯ 81 ◯ 82 ◯ 83

5 ◯ 84 ◯ 85 ◯ 86

6 ◯ 87 ◯ 88 ◯ 89

7 ◯ 90 ◯ 91 ◯ 92

8 ◯ 93 ◯ 94 ◯ 95

PAGE TOTAL []

9. The various audio connectors as shown in this figure are:

Edward Aiona

　　96　　　　97　　　　98　　　　99

a. XLR

9a ○ ○ ○ ○
　　96 97 98 99

b. RCA phono plug

9b ○ ○ ○ ○
　　96 97 98 99

c. mini plug

9c ○ ○ ○ ○
　　96 97 98 99

d. phone plug

9d ○ ○ ○ ○
　　96 97 98 99

PAGE TOTAL	
SECTION TOTAL	

REVIEW OF SOUND RECORDING AND AESTHETICS

Select the correct answers and fill in the bubbles with the corresponding numbers.

1. Indicate the sound characteristics in this waveform with the corresponding numbers.

100 101 102 100 103

 a. sharp loud sounds

 1a ◯ ◯ ◯ ◯
 100 101 102 103

 b. silences

 1b ◯ ◯ ◯ ◯
 100 101 102 103

 c. increasing volume

 1c ◯ ◯ ◯ ◯
 100 101 102 103

2. Matching audio and video energies means to (104) *adjust the strength of the audio signals to those of the video signals* (105) *use similar digital effects in video and audio* (106) *have high- and low-energy audio accompany high- and low-energy video.*

 2 ◯ ◯ ◯
 104 105 106

3. Sound perspective is especially important when the director cuts frequently from (107) *CU to CU* (108) *CU to LS and reverse* (109) *O/S to O/S from the reverse side.*

 3 ◯ ◯ ◯
 107 108 109

4. The figure/ground principle in audio refers to (110) *a person speaking while moving against a stable background* (111) *making the principal sound source as loud as the background sounds* (112) *separating the principal sound source from the background sounds through a higher volume.*

 4 ◯ ◯ ◯
 110 111 112

5. In the figure below, which button would you press to return to the beginning of the track currently playing?

 5 ◯ ◯ ◯ ◯
 113 114 115 116
 ◯ ◯ ◯
 117 118 119

113 114 115 116 117 118 119

SECTION TOTAL []

REVIEW QUIZ

*Mark the following statements as true or false by filling in the bubbles in the **T** (for true) or*
***F** (for false) column.*

		T	F
1.	Digital sound is less sensitive to distortion than analog sound when riding gain between 0 and +1 VU.	1 ◯ 120	◯ 121
2.	Because there are adapters, you don't have to worry about the cable connectors' fitting the equipment jacks.	2 ◯ 122	◯ 123
3.	In EFP you should try to mix the sounds as carefully as possible with the use of a portable mixer.	3 ◯ 124	◯ 125
4.	To test whether a microphone is turned on, you should blow into it.	4 ◯ 126	◯ 127
5.	You should always use AGC when doing a field pickup.	5 ◯ 128	◯ 129
6.	A pencil mic is a good fishpole pickup method for a two-way conversation.	6 ◯ 130	◯ 131
7.	When riding gain, you should keep the VU needle between 60 and 100 (–5 and 0).	7 ◯ 132	◯ 133
8.	Because lavalier microphones are highly sensitive, they work best when hidden under a shirt or blouse.	8 ◯ 134	◯ 135
9.	Digital audio can be recorded on a solid-state (SD) device but not on videotape.	9 ◯ 136	◯ 137
10.	Regardless of whether you work with a mixer or an audio console, each input has its own pot (fader).	10 ◯ 138	◯ 139
11.	Dynamic mics are generally less sensitive to shock and temperature extremes than are condenser mics.	11 ◯ 140	◯ 141
12.	Lavalier microphones are useful for news anchors.	12 ◯ 142	◯ 143
13.	Once you use an external microphone, you should turn off the camera mic.	13 ◯ 144	◯ 145
14.	Riding gain means adjusting the signal so that it continuously reads *0* regardless of the input audio levels.	14 ◯ 146	◯ 147
15.	Line-level inputs are used for relatively strong signals.	15 ◯ 148	◯ 149
16.	All microphones are insensitive to shock once they are turned off.	16 ◯ 150	◯ 151

SECTION TOTAL []

 W-77

PROBLEM-SOLVING APPLICATIONS

1. The new PA tells you that the audio engineer of his former employer used lavalier microphones exclusively on the actors of a college play because lavs would provide excellent sound perspective without driving the audio console operator crazy. Do you agree with this audio engineer? If so, why? If not, why not?

2. While riding gain during a digital live recording of a small rock band, the director is concerned about overmodulation when the VU meters occasionally peak into the +1 red zone. What is your response?

3. You are doing a documentary on police patrols in your city. You first want to hear the conversations and the police radio inside the patrol car and then capture the sounds of possible conversations, yelling, or any other audio when the officers leave the patrol car to confront a suspect. What microphones would you need for optimal sound pickup in these situations?

4. During a short segment of an EFP in an auto assembly plant, the new PA wonders why the audio people do not try mixing the ambient sounds with the voices of the reporter and the plant supervisor right on the spot. He feels that mixing in the field would eliminate the need for a great deal of postproduction sweetening. What are your comments?

5. You are in charge of audio for a show that consists of several intimate numbers by a singer and a small band. After the rehearsal an observer in the control room tells you that the singer holds the mic during the softer passages much too close to her mouth and that she should hold the mic much lower and sing "across" rather than into it. What is your reaction? Why?

6. The EFP director blames the fishpole operator for the excessive wind noise during an outdoor interview. The fishpole operator blames the director for conducting the interview on a windy street corner and insists that even a windsock would not have prevented the wind noise distortion. What is your reaction? Be specific.

Light, Color, and Lighting

REVIEW OF KEY TERMS

Match each term with its appropriate definition by filling in the corresponding bubble.

1. light plot
2. key light
3. color temperature
4. falloff
5. spotlight
6. background light
7. contrast

8. lux
9. floodlight
10. baselight
11. foot-candle
12. additive primary colors
13. cast shadow
14. LED lights

15. photographic principle
16. diffused light
17. fill light
18. attached shadow
19. back light
20. directional light

A. Lighting instrument that produces diffused light

A ○ ○ ○ ○ ○
　 1　2　3　4　5
　 ○ ○ ○ ○ ○
　 6　7　8　9　10
　 ○ ○ ○ ○ ○
　 11　12　13　14　15
　 ○ ○ ○ ○ ○
　 16　17　18　19　20

B. European standard for measuring light intensity

B ○ ○ ○ ○ ○
　 1　2　3　4　5
　 ○ ○ ○ ○ ○
　 6　7　8　9　10
　 ○ ○ ○ ○ ○
　 11　12　13　14　15
　 ○ ○ ○ ○ ○
　 16　17　18　19　20

P A G E
T O T A L []

1. light plot	8. lux	15. photographic principle
2. key light	9. floodlight	16. diffused light
3. color temperature	10. baselight	17. fill light
4. falloff	11. foot-candle	18. attached shadow
5. spotlight	12. additive primary colors	19. back light
6. background light	13. cast shadow	20. directional light
7. contrast	14. LED lights	

C. Even, nondirectional light necessary for the camera to operate optimally; refers to the overall light intensity

C 1 2 3 4 5 6 7 8 9 10 11 12 13 14 15 16 17 18 19 20

D. Lighting instrument that produces directional, relatively undiffused light

D 1 2 3 4 5 6 7 8 9 10 11 12 13 14 15 16 17 18 19 20

E. Illumination of the set pieces and the backdrop

E 1 2 3 4 5 6 7 8 9 10 11 12 13 14 15 16 17 18 19 20

F. Shadow that is produced by an object and thrown on another surface; it can be independent of the object

F 1 2 3 4 5 6 7 8 9 10 11 12 13 14 15 16 17 18 19 20

PAGE TOTAL []

G. The difference between the lightest and the darkest spot in a picture

G ○ ○ ○ ○ ○
　　1　2　3　4　5
　　○ ○ ○ ○ ○
　　6　7　8　9　10
　　○ ○ ○ ○ ○
　11　12　13　14　15
　　○ ○ ○ ○ ○
　16　17　18　19　20

H. The speed (degree) with which a light picture portion turns into shadow areas; it can be fast or slow

H ○ ○ ○ ○ ○
　　1　2　3　4　5
　　○ ○ ○ ○ ○
　　6　7　8　9　10
　　○ ○ ○ ○ ○
　11　12　13　14　15
　　○ ○ ○ ○ ○
　16　17　18　19　20

I. The standard arrangement of key, back, and fill lights, with the back light opposite the camera and directly behind the object, and the key and fill lights on opposite sides of the camera and to the front and side of the object

I ○ ○ ○ ○ ○
　　1　2　3　4　5
　　○ ○ ○ ○ ○
　　6　7　8　9　10
　　○ ○ ○ ○ ○
　11　12　13　14　15
　　○ ○ ○ ○ ○
　16　17　18　19　20

J. A plan, similar to a floor plan, that shows the type and the location of the lighting instruments relative to the scene to be illuminated and the general direction of the beams

J ○ ○ ○ ○ ○
　　1　2　3　4　5
　　○ ○ ○ ○ ○
　　6　7　8　9　10
　　○ ○ ○ ○ ○
　11　12　13　14　15
　　○ ○ ○ ○ ○
　16　17　18　19　20

K. Shadow that is on the object itself; it cannot be seen independent of the object

K ○ ○ ○ ○ ○
　　1　2　3　4　5
　　○ ○ ○ ○ ○
　　6　7　8　9　10
　　○ ○ ○ ○ ○
　11　12　13　14　15
　　○ ○ ○ ○ ○
　16　17　18　19　20

P A G E
T O T A L

1. light plot	8. lux	15. photographic principle
2. key light	9. floodlight	16. diffused light
3. color temperature	10. baselight	17. fill light
4. falloff	11. foot-candle	18. attached shadow
5. spotlight	12. additive primary colors	19. back light
6. background light	13. cast shadow	20. directional light
7. contrast	14. LED lights	

L. Illumination from behind the subject and opposite the camera

L ○ ○ ○ ○ ○
 1 2 3 4 5
 ○ ○ ○ ○ ○
 6 7 8 9 10
 ○ ○ ○ ○ ○
 11 12 13 14 15
 ○ ○ ○ ○ ○
 16 17 18 19 20

M. Light that causes relatively soft shadows

M ○ ○ ○ ○ ○
 1 2 3 4 5
 ○ ○ ○ ○ ○
 6 7 8 9 10
 ○ ○ ○ ○ ○
 11 12 13 14 15
 ○ ○ ○ ○ ○
 16 17 18 19 20

N. Additional light on the opposite side of the camera from the key light to illuminate shadow areas and thereby reduce falloff

N ○ ○ ○ ○ ○
 1 2 3 4 5
 ○ ○ ○ ○ ○
 6 7 8 9 10
 ○ ○ ○ ○ ○
 11 12 13 14 15
 ○ ○ ○ ○ ○
 16 17 18 19 20

O. The American unit for measuring light intensity

O ○ ○ ○ ○ ○
 1 2 3 4 5
 ○ ○ ○ ○ ○
 6 7 8 9 10
 ○ ○ ○ ○ ○
 11 12 13 14 15
 ○ ○ ○ ○ ○
 16 17 18 19 20

P A G E
T O T A L []

Course No. _____	**Date** _____	**Name** _____

P. Red, green, and blue

P
○ ○ ○ ○ ○
1 2 3 4 5
○ ○ ○ ○ ○
6 7 8 9 10
○ ○ ○ ○ ○
11 12 13 14 15
○ ○ ○ ○ ○
16 17 18 19 20

Q. Light source for most computer screens

Q
○ ○ ○ ○ ○
1 2 3 4 5
○ ○ ○ ○ ○
6 7 8 9 10
○ ○ ○ ○ ○
11 12 13 14 15
○ ○ ○ ○ ○
16 17 18 19 20

R. Relative reddishness or bluishness of light, as measured on the Kelvin scale

R
○ ○ ○ ○ ○
1 2 3 4 5
○ ○ ○ ○ ○
6 7 8 9 10
○ ○ ○ ○ ○
11 12 13 14 15
○ ○ ○ ○ ○
16 17 18 19 20

S. Light that causes sharp shadows

S
○ ○ ○ ○ ○
1 2 3 4 5
○ ○ ○ ○ ○
6 7 8 9 10
○ ○ ○ ○ ○
11 12 13 14 15
○ ○ ○ ○ ○
16 17 18 19 20

T. Principal source of illumination

T
○ ○ ○ ○ ○
1 2 3 4 5
○ ○ ○ ○ ○
6 7 8 9 10
○ ○ ○ ○ ○
11 12 13 14 15
○ ○ ○ ○ ○
16 17 18 19 20

PAGE TOTAL []

SECTION TOTAL []

REVIEW OF LIGHT, SHADOWS, AND COLOR

Select the correct answers and fill in the bubbles with the corresponding numbers.

1. Baselight levels are measured in (21) *lux* (22) *foot-candles* (23) *f-stops.* **(Multiple answers are possible.)**

 1 ○ 21 ○ 22 ○ 23

2. Electronic white balance (24) *makes a white object look white in a video camera regardless of the relative color temperature of the light* (25) *controls extremely bright spots in the picture* (26) *adjusts the brightness in the viewfinder.*

 2 ○ 24 ○ 25 ○ 26

3. One foot-candle is approximately (27) *5* (28) *10* (29) *15* lux.

 3 ○ 27 ○ 28 ○ 29

4. When measuring reflected light, you must stand next to the lighted object and point the light meter (30) *toward the camera lens* (31) *toward the object from the direction of the camera* (32) *into the lights.*

 4 ○ 30 ○ 31 ○ 32

5. Fast falloff means that there is (33) *a great difference between the light side and the attached-shadow side of the object* (34) *a great difference between the light side and the cast shadow* (35) *little difference between the light side and the attached-shadow side of the object.*

 5 ○ 33 ○ 34 ○ 35

6. When lighting for slow falloff in large areas, you should use predominantly (36) *directional* (37) *diffused* (38) *high-color-temperature* light.

 6 ○ 36 ○ 37 ○ 38

7. The standard color temperature for outdoor lighting is (39) *3,200K* (40) *3,600K* (41) *5,600K.*

 7 ○ 39 ○ 40 ○ 41

8. Contrast is measured by reading the (42) *brightest and darkest areas in the scene* (43) *highest and lowest color temperatures in a scene* (44) *foreground light and background light.*

 8 ○ 42 ○ 43 ○ 44

9. When lowering the color temperature, the white light becomes more (45) *reddish* (46) *greenish* (47) *bluish.*

 9 ○ 45 ○ 46 ○ 47

10. When all three electron guns in a color monitor hit the three additive color dots at maximum intensity, the screen will be (48) *white* (49) *black* (50) *multicolored.*

 10 ○ 48 ○ 49 ○ 50

11. When measuring incident light, you must stand next to the lighted object and point the light meter (51) *toward the camera lens* (52) *toward the object* (53) *toward the background.*

 11 ○ 51 ○ 52 ○ 53

12. A high color temperature means that the light has a (54) *reddish* (55) *bluish* (56) *greenish* tinge.

 12 ○ 54 ○ 55 ○ 56

13. The standard color temperature for indoor lighting is (57) *3,200K* (58) *3,600K* (59) *5,600K.*

 13 ○ 57 ○ 58 ○ 59

SECTION TOTAL []

REVIEW OF LIGHTING INSTRUMENTS

Select the correct answers and fill in the bubbles with the corresponding numbers.

1. A scoop has (60) *a Fresnel lens* (61) *no lens* and (62) *a focus control* (63) *no focus control.* **(Fill in two bubbles.)**

 1 ○ ○ ○ ○
 60 61 62 63

2. Open-face portable spotlights have (64) *a Fresnel lens* (65) *no lens* and (66) *a reflector* (67) *no reflector.* **(Fill in two bubbles.)**

 2 ○ ○ ○ ○
 64 65 66 67

3. The flooded beam has (68) *more* (69) *less* intensity than the focused beam.

 3 ○ ○
 68 69

4. To flood (spread) the light beam of a Fresnel spotlight, you need to move the lamp-reflector unit (70) *toward* (71) *away from* the lens; to focus the beam more narrowly, move it (72) *toward* (73) *away from* the lens. **(Fill in two bubbles.)**

 4 ○ ○ ○ ○
 70 71 72 73

P A G E
T O T A L []

5. Fill in the bubbles whose numbers correspond with the appropriate lighting instruments shown below:

74

Mole-Richardson Co.

75

Herbert Zettl

76

Lowel-Light Manufacturing, Inc.

77

Lowel-Light Manufacturing, Inc.

Herbert Zettl

78

Mole-Richardson Co.

79

Mole-Richardson Co.

80

81

Herbert Zettl

82

Lowel-Light Manufacturing, Inc.

83

Lowel-Light Manufacturing, Inc.

a. Omni-light

b. scoop

5a
○ ○ ○ ○ ○
74 75 76 77 78
○ ○ ○ ○ ○
79 80 81 82 83

5b
○ ○ ○ ○ ○
74 75 76 77 78
○ ○ ○ ○ ○
79 80 81 82 83

PAGE TOTAL []

c. fluorescent bank

5c ○ ○ ○ ○ ○
 74 75 76 77 78
○ ○ ○ ○ ○
79 80 81 82 83

d. softlight

5d ○ ○ ○ ○ ○
 74 75 76 77 78
○ ○ ○ ○ ○
79 80 81 82 83

e. diffusion tent

5e ○ ○ ○ ○ ○
 74 75 76 77 78
○ ○ ○ ○ ○
79 80 81 82 83

f. Fresnel spotlight

5f ○ ○ ○ ○ ○
 74 75 76 77 78
○ ○ ○ ○ ○
79 80 81 82 83

g. clip light

5g ○ ○ ○ ○ ○
 74 75 76 77 78
○ ○ ○ ○ ○
79 80 81 82 83

h. EFP floodlight (V-light)

5h ○ ○ ○ ○ ○
 74 75 76 77 78
○ ○ ○ ○ ○
79 80 81 82 83

i. ellipsoidal spotlight

5i ○ ○ ○ ○ ○
 74 75 76 77 78
○ ○ ○ ○ ○
79 80 81 82 83

j. LED light panel

5j ○ ○ ○ ○ ○
 74 75 76 77 78
○ ○ ○ ○ ○
79 80 81 82 83

P A G E TOTAL []

SECTION TOTAL []

REVIEW OF LIGHTING TECHNIQUES

Select the correct answers and fill in the bubbles with the corresponding numbers.

1. The arrangement of lighting instruments shown in the figure below is generally called
(84) *triangle lighting or the basic photographic principle* (85) *photographic lighting*
(86) *the field lighting principle.*

1 ◯ ◯ ◯
 84 85 86

Camera

2. Fill in the bubbles whose numbers correspond with the functions of the lighting
instruments shown in the figure above and whether they are usually (90) *spotlights* or
(91) *floodlights.* **(Fill in two bubbles.)**

 a. back

2a ◯ ◯ ◯
 87 88 89
 ◯ ◯
 90 91

 b. fill

2b ◯ ◯ ◯
 87 88 89
 ◯ ◯
 90 91

 c. key

2c ◯ ◯ ◯
 87 88 89
 ◯ ◯
 90 91

P A G E
T O T A L []

3. What major light sources were used for illuminating the on-screen person in the following three pictures? In the diagrams, circle the instrument or instruments used, then fill in the bubbles whose numbers correspond with the instruments used to light the subject. *(Multiple answers are possible.)*

a.

3a ○ ○ ○ ○
 92 93 94 95

b.

3b ○ ○ ○ ○
 96 97 98 99

PAGE
TOTAL

c.

Edward Aiona

100 101 102 103

d.

Edward Aiona

104 105 106 107

4. When shooting an ENG interview in bright sunlight, the most convenient fill light is a (108) *large spot* (109) *scoop* (110) *reflector.*

4 ○ ○ ○
 108 109 110

5. Having somebody stand in front of a brightly illuminated building will (111) *provide much-needed back light* (112) *help separate the person from the background* (113) *cause an undesirable silhouette effect.*

5 ○ ○ ○
 111 112 113

6. When trying to match the color temperature of outdoor light coming into a room through a window with that of your standard portable floodlights, you need to (114) *lower* (115) *raise* the color temperature of your indoor lights by putting (116) *an amber (warm orange)* (117) *a light blue* gel (filter) in front of all indoor instruments. *(Fill in two bubbles.)*

6 ○ ○ ○ ○
 114 115 116 117

PAGE
TOTAL

SECTION
TOTAL

© 2013 Cengage Learning

REVIEW QUIZ

*Mark the following statements as true or false by filling in the bubbles in the **T** (for true) or*
***F** (for false) column.*

		T	F
1. An overcast day produces low-contrast lighting.	**1**	○ 118	○ 119
2. Portable openface lights have no lens.	**2**	○ 120	○ 121
3. LED flat panels are similar to softlights.	**3**	○ 122	○ 123
4. Floodlights are the quickest way to illuminate a large area with even light.	**4**	○ 124	○ 125
5. All professional floodlights have Fresnel lenses.	**5**	○ 126	○ 127
6. Color temperature refers to how hotly a light burns.	**6**	○ 128	○ 129
7. The background light must strike the background from the same side as the key light.	**7**	○ 130	○ 131
8. Barn doors are primarily used to slow down falloff.	**8**	○ 132	○ 133
9. You can use a floodlight for a key.	**9**	○ 134	○ 135
10. Fluorescent banks produce fast falloff.	**10**	○ 136	○ 137
11. C-clamps are built for mounting spotlights but not floodlights.	**11**	○ 138	○ 139
12. An amber or orange gel in front of a lighting instrument will raise its color temperature.	**12**	○ 140	○ 141
13. The more fill light, the slower the falloff.	**13**	○ 142	○ 143
14. The best lighting instrument for EFP is the 2,000-watt Fresnel spotlight.	**14**	○ 144	○ 145
15. High-key lighting means that the key light is situated above eye level.	**15**	○ 146	○ 147
16. We measure color temperature on the Kelvin scale.	**16**	○ 148	○ 149
17. We measure incident light by pointing the light meter close to the lighted object.	**17**	○ 150	○ 151
18. Softlights can focus their light beam.	**18**	○ 152	○ 153
19. Back lights and background lights fulfill similar functions.	**19**	○ 154	○ 155
20. Fill lights can easily be substituted with reflectors.	**20**	○ 156	○ 157

SECTION TOTAL ☐

PROBLEM-SOLVING APPLICATIONS

1. You are asked to do the lighting for a shampoo commercial. The director wants you to make the model's blond hair look especially brilliant and glamorous. Which of the three instruments of the lighting triangle needs special attention to achieve the desired result?

2. You have very little time to light a five-member panel discussion in the multipurpose room of the local elementary school. The board members sit side-by-side behind a long table. What lighting type would you employ? What instruments would you use? Why?

3. The director of a studio interview with a prize-winning actor suggests using a softlight as the key instead of a Fresnel spot. What is your reaction? Be specific.

4. You are asked to video-record the president of a new computer company who wants to talk to her employees from behind her desk. The vice president tells you not to worry about the large window behind the president's chair because you can use the daylight streaming through the window as interesting back light. What is your reaction? What problems, if any, do you anticipate? What solutions would you suggest?

5. The novice assistant director is very worried about video-recording the high-school graduation ceremony. He said that the overcast sky will cause fast falloff and is prone to color distortion in the shadow areas. What is your reaction? Why?

6. The news director wants you, the LD, to try out new LED flat panels to achieve slow falloff and save electricity. Do you agree with him? If so, why? If not, why not?

Graphics and Effects

REVIEW OF KEY TERMS

Match each term with its appropriate definition by filling in the corresponding bubble.

1. chroma key
2. aspect ratio
3. wipe
4. matte key

5. essential area
6. super
7. ESS system

8. DVE
9. key
10. CG

A. A computer dedicated to the creation of letters and numbers for titles

A ○ ○ ○ ○ ○
 1 2 3 4 5
 ○ ○ ○ ○ ○
 6 7 8 9 10

B. The section of the screen seen by the home viewer despite a badly aligned TV set

B ○ ○ ○ ○ ○
 1 2 3 4 5
 ○ ○ ○ ○ ○
 6 7 8 9 10

C. The simultaneous overlay of two pictures on the same screen

C ○ ○ ○ ○ ○
 1 2 3 4 5
 ○ ○ ○ ○ ○
 6 7 8 9 10

D. The width-to-height relationship of a video screen

D ○ ○ ○ ○ ○
 1 2 3 4 5
 ○ ○ ○ ○ ○
 6 7 8 9 10

PAGE TOTAL []

1. chroma key	5. essential area	8. DVE
2. aspect ratio	6. super	9. key
3. wipe	7. ESS system	10. CG
4. matte key		

E. A transition in which one image gradually replaces the other on the screen in various configurations

E
○ ○ ○ ○ ○
1　2　3　4　5
○ ○ ○ ○ ○
6　7　8　9　10

F. Letters of a keyed title are filled with gray or a specific color through a third video source

F
○ ○ ○ ○ ○
1　2　3　4　5
○ ○ ○ ○ ○
6　7　8　9　10

G. Video effects generated by a computer

G
○ ○ ○ ○ ○
1　2　3　4　5
○ ○ ○ ○ ○
6　7　8　9　10

H. Analog electronic visual effect in which letters are cut into a base picture, making the letters seem to be printed on top of the background scene

H
○ ○ ○ ○ ○
1　2　3　4　5
○ ○ ○ ○ ○
6　7　8　9　10

I. Special effect that uses color (usually blue or green) for the backdrop of the source (foreground picture); all blue or green areas are replaced by the base picture

I
○ ○ ○ ○ ○
1　2　3　4　5
○ ○ ○ ○ ○
6　7　8　9　10

J. Stores many still video frames in digital form for easy access

J
○ ○ ○ ○ ○
1　2　3　4　5
○ ○ ○ ○ ○
6　7　8　9　10

P A G E T O T A L	
S E C T I O N **T O T A L**	

REVIEW OF STANDARD ELECTRONIC EFFECTS

1. Fill in the bubbles whose numbers correspond with the buttons you would have to press on the pattern selector to create the various effects (**a** through **e**) illustrated in the following figures. *(Note that some numbered buttons do not apply.)*

a.

1a
○ ○ ○ ○ ○
11 12 13 14 15
○ ○ ○ ○ ○
16 17 18 19 20

b.

1b
○ ○ ○ ○ ○
11 12 13 14 15
○ ○ ○ ○ ○
16 17 18 19 20

PAGE TOTAL ☐

Edward Aiona

c.

Edward Aiona

d.

Edward Aiona

e.

Edward Aiona

PAGE
TOTAL

2. Fill in the bubbles whose numbers correspond with the appropriate electronic effects shown in the following figures.

21

22

23

24

25

a. solarization

b. fly effect

c. horizontal stretching

d. cube effect

e. mosaic effect

2a ○ ○ ○ ○ ○
 21 22 23 24 25

2b ○ ○ ○ ○ ○
 21 22 23 24 25

2c ○ ○ ○ ○ ○
 21 22 23 24 25

2d ○ ○ ○ ○ ○
 21 22 23 24 25

2e ○ ○ ○ ○ ○
 21 22 23 24 25

| PAGE TOTAL | |
| SECTION TOTAL | |

REVIEW QUIZ

*Mark the following statements as true or false by filling in the bubbles in the **T** (for true) or **F** (for false) column.*

		T	F
1.	Readability becomes an issue especially when the background is quite busy.	1 ○ 26	○ 27
2.	The ESS system functions like a large slide library and superfast slide projector.	2 ○ 28	○ 29
3.	You can achieve a split-screen effect by stopping a horizontal wipe midway.	3 ○ 30	○ 31
4.	You can use a green backdrop for a chroma key.	4 ○ 32	○ 33
5.	When chroma-keying with a blue backdrop, the person who is to be keyed must wear blue.	5 ○ 34	○ 35
6.	Before the CG can be used for a title, you must print the title on a studio card.	6 ○ 36	○ 37
7.	The titles for a normal, or luminance, key must have a strong brightness contrast with the background.	7 ○ 38	○ 39
8.	Horizontal and vertical stretching can be done only with a digital signal.	8 ○ 40	○ 41
9.	In a mosaic effect, the size of the "tiles" can be manipulated.	9 ○ 42	○ 43
10.	Filling keyed letters with a specific color is called a matte key.	10 ○ 44	○ 45
11.	When matching color energies, we are especially concerned about color harmony.	11 ○ 46	○ 47
12.	The aspect ratio of STV is 4 × 9.	12 ○ 48	○ 49
13.	A fly effect is possible only with DVE.	13 ○ 50	○ 51
14.	In DTV you don't have to worry about the essential area.	14 ○ 52	○ 53
15.	In the fly mode, the image can zoom only from small to large.	15 ○ 54	○ 55
16.	The entire essential area must be filled with an image to show up on the TV screen.	16 ○ 56	○ 57
17.	The aspect ratio of HDTV is 16 × 9.	17 ○ 58	○ 59
18.	A mosaic effect can be achieved with an analog special-effects generator.	18 ○ 60	○ 61
19.	Show titles should be appropriate for the style of the program.	19 ○ 62	○ 63

SECTION TOTAL ☐

PROBLEM-SOLVING APPLICATIONS

1. The AD informs the director that a dancer, who is supposed to be chroma-keyed over a video-recorded cityscape scene, is wearing a saturated blue leotard. The director is quite concerned about this news but is assured by the floor manager that she and the TD have already taken care of the problem. What was the director concerned about? How did the floor manger and the TD resolve it?

2. The preview monitor shows that the title key is barely visible against the busy background because the letters of the key are almost as dark as the background and similar in hue. What would you, the director, suggest to the CG operator to make the key more legible?

3. You are the director of a new international interview show. Although the three guests do not normally come to the studio personally but participate in the interview via satellite hookup, you nevertheless want each guest, when interviewed, to appear on the same screen with the interviewer. The TD tells you that this cannot be done because the switcher is not equipped with DVE equipment. What is your response?

4. Your client wants you to have his new line of automobiles rotate on a cube. How could you meet his request? What equipment would you need?

5. The producer of a documentary on the homeless asks the CG operator to redesign the titles because they are not befitting the style of the show. What does she mean? Give examples.

P A R T

IV

Image Control:
Switching, Recording, and Editing

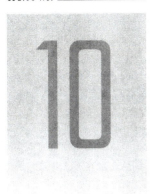

Switcher and Switching

REVIEW OF KEY TERMS

Match each term with its appropriate definition by filling in the corresponding bubble.

1. program bus
2. mix bus
3. key bus

4. preview bus
5. fader bar
6. DSK

7. switching
8. line-out
9. switcher

A. A panel with rows of buttons that allow the selection and the assembly of various video sources

A ○ ○ ○ ○ ○
 1 2 3 4 5
 ○ ○ ○ ○
 6 7 8 9

B. Rows of buttons that permit a super

B ○ ○ ○ ○ ○
 1 2 3 4 5
 ○ ○ ○ ○
 6 7 8 9

C. A change from one video source to another and the creation of various transitions during the production

C ○ ○ ○ ○ ○
 1 2 3 4 5
 ○ ○ ○ ○
 6 7 8 9

D. A lever on the switcher that produces transitions and effects of different speeds

D ○ ○ ○ ○ ○
 1 2 3 4 5
 ○ ○ ○ ○
 6 7 8 9

**P A G E
T O T A L** []

 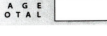

1. program bus	4. preview bus	7. switching
2. mix bus	5. fader bar	8. line-out
3. key bus	6. DSK	9. switcher

E. A control that allows captions to be keyed over the picture (line-out signal) as it leaves the switcher

E
○ ○ ○ ○ ○
1 2 3 4 5
○ ○ ○ ○
6 7 8 9

F. Row of buttons to select the video source to be inserted into the background image

F
○ ○ ○ ○ ○
1 2 3 4 5
○ ○ ○ ○
6 7 8 9

G. Carries the final video and audio signal to the video recorder or transmitter

G
○ ○ ○ ○ ○
1 2 3 4 5
○ ○ ○ ○
6 7 8 9

H. Row of buttons that can direct an input to the preview/preset monitor

H
○ ○ ○ ○ ○
1 2 3 4 5
○ ○ ○ ○
6 7 8 9

I. Row of buttons with inputs that are directly switched to the line-out

I
○ ○ ○ ○ ○
1 2 3 4 5
○ ○ ○ ○
6 7 8 9

PAGE TOTAL

SECTION TOTAL

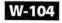

PART IV IMAGE CONTROL: SWITCHING, RECORDING, AND EDITING

REVIEW OF BASIC SWITCHER OPERATION

1. Fill in the bubbles whose numbers correspond with the appropriate parts of the switcher shown in the following figure.

Edward Aiona

a. key bus

1a ○ ○ ○ ○
 10 11 12 13
 ○ ○ ○ ○
 14 15 16 17

b. delegation controls (mix, wipe, key)

1b ○ ○ ○ ○
 10 11 12 13
 ○ ○ ○ ○
 14 15 16 17

c. wipe pattern selector

1c ○ ○ ○ ○
 10 11 12 13
 ○ ○ ○ ○
 14 15 16 17

P A G E
T O T A L

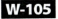

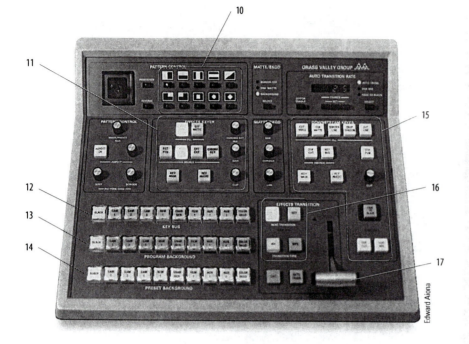

Edward Aiona

d. fader bar

e. key/matte controls

f. program bus

g. preview bus

h. downstream keyer controls

PAGE
TOTAL []

© 2013 Cengage Learning

2. Assuming that the switcher diagrams below are portions of a real switcher, you will see that several buttons have already been pressed. Some are high tally (fully lighted); others are low tally (dimly lighted). C1 is shooting a close-up of the newscaster, and C2 is framing a three-shot of the in-studio guests. (See monitor images below.) Select the correct monitor pair you would expect to see from the switcher output by filling in the corresponding bubbles.

2 ○ ○ ○
 18 19 20

18

Preview Line

19

Preview Line

20

Preview Line

PAGE TOTAL []

3. Select the correct monitor pair you would expect to see from the switcher output by filling in the corresponding bubbles.

3 ◯ 21 ◯ 22 ◯ 23

21

Preview Line

22

Preview Line

23

Preview Line

PAGE TOTAL

Select the correct answers and fill in the bubbles with the corresponding numbers.

4. To select the functions of a specific bus or buses, you need to activate the (24) *specific delegation controls* (25) *wipe pattern selector* (26) *downstream keyer.*

4 ◯ ◯ ◯
24 25 26

5. Assuming that camera 1 is on the air, you can cut to the VR by pressing the (27) *VR button* (28) *CUT button* (29) *KEY button* on the program bus.

5 ◯ ◯ ◯
27 28 29

6. The program bus will direct the selected video source to the (30) *preview monitor* (31) *line-out* (32) *mix bus.*

6 ◯ ◯ ◯
30 31 32

7. Assuming that you are working with a Grass Valley 100 switcher, you press the (33) *DSK and CUT* (34) *BKGD and MIX* (35) *KEY and MIX* buttons to activate the mix function of the preset and program buses.

7 ◯ ◯ ◯
33 34 35

8. To put the screen to black when the title was keyed with the DSK, you need to press the (36) *BLK button in the downstream keyer section* (37) *BLK button on the key bus* (38) *BLK button on the program bus*.

8 ◯ ◯ ◯
36 37 38

PAGE TOTAL

SECTION TOTAL

REVIEW QUIZ

*Mark the following statements as true or false by filling in the bubbles in the **T** (for true) or **F** (for false) column.*

 T **F**

1. When pushing the *BLK* button on the program bus, the line-out monitor goes to black even if the credits were generated by the downstream keyer. — **1** ○ 39 ○ 40

2. The program bus on a switcher sends the selected source directly to the line-out. — **2** ○ 41 ○ 42

3. With a downstream keyer, you can add another title to one already created by the regular key bus before punching up both on the air. — **3** ○ 43 ○ 44

4. If so delegated, the program bus can become the key bus. — **4** ○ 45 ○ 46

5. You can assign the key bus a mix function. — **5** ○ 47 ○ 48

6. You can switch a cuts-only program entirely on the program bus. — **6** ○ 49 ○ 50

7. If so delegated, the preview bus can become one of the mix buses. — **7** ○ 51 ○ 52

8. The key is one of the more useful transitions. — **8** ○ 53 ○ 54

9. The length of the dissolve depends on how fast you move the fader bar from one end of travel to the other. — **9** ○ 55 ○ 56

10. The switcher has a separate button for each input. — **10** ○ 57 ○ 58

11. The *AUTO TRANS* button on a switcher fulfills the same function as the fader bar. — **11** ○ 59 ○ 60

12. Everything punched up on the key bus will go directly to the line-out. — **12** ○ 61 ○ 62

SECTION TOTAL []

PROBLEM-SOLVING APPLICATIONS

1. The director asks you, the TD, to superimpose a long shot of a dancer over a close-up of her face. First the director wants to have the long shot as the more prominent image and then slowly shift the emphasis in the super to the close-up. How, if at all, can you accomplish such an effect?

2. The director would like to have the total scene reveal itself gradually as though we were looking through a progressively expanding rectangle. She asks you to have the small rectangle start in the center of the screen with the proper TV aspect ratio and then expand to the full-size television screen. How, if at all, could you achieve this effect?

3. The producer would like to have an old-fashioned "The End" supered over the final shot of a chroma-keyed patio setting. He asks you, the TD, whether you can meet his request. How, if at all, could you achieve this effect?

4. In the multicamera live-recorded presentation of a highly precise balletlike dance piece, the director would like to use dissolves of exactly the same speed for all transitions. Can you do this? If so, how?

5. The same director would like to have several extremely quick cutting sequences during the argument scene between the prosecution and defense attorneys. She plans to cover the argument in tight cross-shots. How would you set up the switcher for these sequences?

6. Using your switcher, note which architectural elements are similar to those of the Grass Valley 100 as pictured in this workbook and which are not.

7. Practice setting up, storing, and recalling special effects.

11 Video Recording

▌ REVIEW OF KEY TERMS

Match each term with its appropriate definition by filling in the corresponding bubble.

1. audio track
2. video track
3. field log
4. Y/C component video
5. composite video
6. tapeless systems

7. pocket recorder
8. nonlinear recording media
9. TBC
10. luminance
11. control track

12. Y/color difference component video
13. NTSC
14. memory card
15. video server

A. Small camcorder that records exclusively on memory cards

A
○ ○ ○ ○ ○
1　2　3　4　5
○ ⊙ ○ ○ ○
6　7　8　9　10
○ ○ ○ ○ ○
11　12　13　14　15

B. A record of each take during the video-recording

B
○ ○ ⊙ ○ ○
1　2　3　4　5
○ ○ ○ ○ ○
6　7　8　9　10
○ ○ ○ ○ ○
11　12　13　14　15

C. For the storage of video and audio material in digital form on a hard drive or read/write optical disc; each frame can be accessed by the computer independent of all others

C
○ ○ ○ ○ ○
1　2　3　4　5
○ ○ ⊙ ○ ○
6　7　8　9　10
○ ○ ○ ○ ○
11　12　13　14　15

P A G E
T O T A L　[]

1. audio track	7. pocket recorder	12. Y/color difference component video
2. video track	8. nonlinear recording media	13. NTSC
3. field log	9. TBC	14. memory card
4. Y/C component video	10. luminance	15. video server
5. composite video	11. control track	
6. tapeless systems		

D. Allow the recording, storage, and playback of audio and video information via digital storage devices other than videotape

D ① ② ③ ④ ⑤ (1 2 3 4 5)
⊙ ○ ○ ○ ○ (6 7 8 9 10)
○ ○ ○ ○ ○ (11 12 13 14 15)

E. A system that separates the Y and C signals and treats the luminance and color as separate signals but combines them during the recording

E ○ ○ ○ ○ ○ (1 2 3 4 5)
○ ○ ○ ○ ○ (6 7 8 9 10)
○ ○ ○ ○ ○ (11 12 13 14 15)

F. Stands for *National Television System Committee;* designates the composite signal system

F ○ ○ ○ ○ ○ (1 2 3 4 5)
○ ○ ○ ○ ○ (6 7 8 9 10)
○ ○ ○ ○ ○ (11 12 13 14 15)

G. The area of the videotape used for recording the video information

G ○ ⊙ ○ ○ ○ (1 2 3 4 5)
○ ○ ○ ○ ○ (6 7 8 9 10)
○ ○ ○ ○ ○ (11 12 13 14 15)

H. A device that makes videotape edits and playback more stable

H ○ ○ ○ ○ ○ (1 2 3 4 5)
○ ○ ○ ⊙ ○ (6 7 8 9 10)
○ ○ ○ ○ ○ (11 12 13 14 15)

PAGE TOTAL []

I. The area of the videotape used for recording the audio information

I ⊙ ○ ○ ○ ○
1 2 3 4 5
○ ○ ○ ○ ○
6 7 8 9 10
○ ○ ○ ○ ○
11 12 13 14 15

J. A high-capacity hard drive system for storage and playback of video programs

J ○ ○ ○ ○ ○
1 2 3 4 5
○ ○ ○ ○ ○
6 7 8 9 10
○ ○ ○ ○ ⊙
11 12 13 14 15

K. A solid-state read/write digital storage media of limited capacity

K ○ ○ ○ ○ ○
1 2 3 4 5
○ ○ ○ ○ ○
6 7 8 9 10
○ ○ ○ ⊙ ○
11 12 13 14 15

L. A system that combines the Y (black-and-white) and C (red, green, and blue) video information into a single signal

L ○ ○ ○ ⊙ ○
1 2 3 4 5
○ ○ ○ ○ ○
6 7 8 9 10
○ ○ ○ ○ ○
11 12 13 14 15

M. The track that contains the sync pulses

M ○ ○ ○ ○ ○
1 2 3 4 5
○ ○ ○ ○ ○
6 7 8 9 10
⊙ ○ ○ ○ ○
11 12 13 14 15

N. A system that keeps the Y and two manipulated C signals separate throughout the video-recording process

N ○ ○ ○ ○ ○
1 2 3 4 5
○ ○ ○ ○ ○
6 7 8 9 10
○ ⊙ ○ ○ ○
11 12 13 14 15

P A G E
T O T A L

1. audio track	7. pocket recorder	12. Y/color difference
2. video track	8. nonlinear recording media	component video
3. field log	9. TBC	13. NTSC
4. Y/C component video	10. luminance	14. memory card
5. composite video	11. control track	15. video server
6. tapeless systems		

O. The brightness information of a video signal

O ○ ○ ○ ○ ○
 1 2 3 4 5
 ○ ○ ○ ○ ○
 6 7 8 9 10
 ○ ○ ○ ○ ○
 11 12 13 14 15

REVIEW OF VIDEO-RECORDING SYSTEMS

Select the correct answers and fill in the bubbles with the corresponding numbers.

1. A single digital frame on videotape is made up of (16) *four fields* (17) *10 or more tracks* (18) *four analog frames.*

 1 ⊙ 16 ○ 17 ○ 18

2. The Y/C color difference is primarily used to (19) *preserve image quality* (20) *emphasize the difference between black-and-white and color* (21) *show the differences in hue.*

 2 ⊙ 19 ○ 20 ○ 21

3. The Y/C system is (22) *composite* (23) *component* during transport.

 3 ○ 22 ○ 23

4. The Y signal is normally color coded as (24) *yellow* (25) *blue* (26) *green.*

 4 ⊙ 24 ○ 25 ○ 26

5. The Y/color difference signal is (27) *composite* (28) *component.*

 5 ○ 27 ⊙ 28

6. Videotape can record (29) *digital information only* (30) *analog information only* (31) *both digital and analog information.*

 6 ○ 29 ○ 30 ⊙ 31

7. A memory card operates with (32) *an optical disc drive* (33) *a hard disk drive* (34) *no moving parts.*

 7 ○ 32 ○ 33 ○ 34

8. To keep the quality loss to a minimum during extensive postproduction editing using videotape, you should use (35) *analog* (36) *digital* VRs and a (37) *composite* (38) *component* system. ***(Fill in two bubbles.)***

 8 ○ 35 ⊙ 36 ○ 37 ○ 38

9. A TBC (39) *synchronizes the scanning of various video sources* (40) *calibrates the clocks in the control room* (41) *adjusts the log times in the video server.*

 9 ⊙ 39 ○ 40 ○ 41

10. Compared with a hard drive, a memory card has (42) *a greater* (43) *a smaller* (44) *about the same* storage capacity.

 10 ○ 42 ⊙ 43 ○ 44

SECTION TOTAL []

REVIEW OF THE VIDEO-RECORDING PROCESS

Select the correct answers and fill in the bubbles with the corresponding numbers.

1. Identify lines in the field log below that contain obvious errors in the time code, evaluation (OK or no good), or recording order. *(Multiple answers are possible.)*

	MEDIA NUMBER	SCENE	TAKE	OK or NO GOOD	TIME CODE		EVENT / REMARKS
					IN	OUT	
45	P2-1	3	2	OK	01:51:25	02:09:11	Stuart z-axis board walk
46			1	OK	02:27:01	02:37:19	CU Stuart
47			3	OK	04:59:29	05:17:16	Street: Stage coach Jet plane AUDIO problem
48			4	NG	05:35:20	06:17:17	Bill FOCUS problem z-axis board walk -
49			5	OK	06:30:12	06:28:26	Bill 2-axis board walk
50			6	OK	07:29:03	07:39:13	Bill CU
51	P2-2	6	1	NG	07:59:18	08:30:59	Ext: Saloon Horse in shot -
52			2	OK	08:38:28	09:15:12	Ext: Saloon

PRODUCTION TITLE: History Series: Gold Rush PRODUCER/DIRECTOR: Elan Frank

RECORDING DATE: 07/15 LOCATION: Virginia City, Nevada

a. time code error

b. recording order error

c. evaluation (OK/NG) error

1a ○ ○ ○ ○
 45 46 47 48
 ○ ○ ○ ○
 49 50 51 52

1b ○ ○ ○ ○
 45 46 47 48
 ○ ○ ○ ○
 49 50 51 52

1c ○ ○ ○ ○
 45 46 47 48
 ○ ○ ○ ○
 49 50 51 52

PAGE TOTAL ☐

2. The most common professional video connectors are (53) *XLR* (54) *mini plug* (55) *BNC* (56) *RCA phono.* **(Multiple answers are possible.)**

2 ○ ○ ○ ○
 53 54 55 56

3. Color bars are useful only when they are (57) *generated by the equipment you are actually using for the program recording* (58) *dubbed from a color bar master tape* (59) *digitally generated.*

3 ○ ○ ○
 57 58 59

4. Mark the items that are part of a normal video leader: (60) *color bars* (61) *identification slate* (62) *control track display* (63) *test tone* (64) *edit decision list* (65) *video test pattern.* **(Multiple answers are possible.)**

4 ○ ○ ○
 60 61 62
 ○ ○ ○
 63 64 65

5. To record on a memory card, the protection tab must be in the (66) *open* (67) *closed* position.

5 ○ ○
 66 67

P A G E
T O T A L []

SECTION
T O T A L []

REVIEW OF NONLINEAR STORAGE SYSTEMS

Select the correct answers and fill in the bubbles with the corresponding numbers.

1. Indicate which of the following video storage devices is linear: (68) *DVD* (69) *hard drive* (70) *videotape* (71) *video server.*

 1 ◯ ◯ ◯ ◯
 68 69 70 71

2. Of the following, the "read-only" digital storage device is a (72) *memory card* (73) *hard drive* (74) *digital VTR* (75) *standard CD-ROM.*

 2 ◯ ◯ ◯ ◯
 72 73 74 75

3. The ESS system can grab and digitize a video frame (76) *only from a digital videotape* (77) *only from an analog videotape* (78) *from any video source.*

 3 ◯ ◯ ◯
 76 77 78

4. The optical storage device that you can erase and reuse for a new recording of video and audio information is a (79) *CD-R* (80) *DVD* (81) *DVD-RW.*

 4 ◯ ◯ ◯
 79 80 81

5. Memory card recordings are (82) *linear* (83) *nonlinear* and (84) *allow* (85) *do not allow* random access. *(Fill in two bubbles.)*

 5 ◯ ◯ ◯ ◯
 82 83 84 85

6. The recording system that has no moving parts is (86) *a memory card* (87) *an optical disc* (88) *a digital videotape.*

 6 ◯ ◯ ◯
 86 87 88

SECTION TOTAL []

REVIEW QUIZ

*Mark the following statements as true or false by filling in the bubbles in the **T** (for true) or
F (for false) column.*

		T	F
1.	A memory card has a larger storage capacity than a hard drive.	**1** ○ 89	○ 90
2.	Color bars help in adjusting the colors on the playback monitor.	**2** ○ 91	○ 92
3.	*NTSC signal* and *composite signal* mean the same thing.	**3** ○ 93	○ 94
4.	The Y/C component system means that the color yellow has been added to the color signals.	**4** ○ 95	○ 96
5.	The video leader must include a 0 VU test tone.	**5** ○ 97	○ 98
6.	A TBC helps eliminate picture jitter.	**6** ○ 99	○ 100
7.	A recorded clapboard helps locate clips in postproduction.	**7** ○ 101	○ 102
8.	Y, R–Y, B–Y is a component video signal.	**8** ○ 103	○ 104
9.	In a Y/color difference component system, the primary color signals are kept separate throughout the recording process.	**9** ○ 105	○ 106
10.	All digital videotapes are linear storage devices.	**10** ○ 107	○ 108
11.	A video leader should always be dubbed over from a master recording of standard video leaders.	**11** ○ 109	○ 110
12.	Y/C component video and S-video are the same.	**12** ○ 111	○ 112
13.	Contrary to a VR log, a field log does not need time code numbers.	**13** ○ 113	○ 114
14.	Dubbing analog videotape produces much more deterioration from one generation to the next than when dubbing digital videotape.	**14** ○ 115	○ 116
15.	A memory card has no moving parts.	**15** ○ 117	○ 118
16.	When recorded on a memory card, the content can be played back even if the record-protect tab is in the closed position.	**16** ○ 119	○ 120

SECTION
TOTAL

PROBLEM-SOLVING APPLICATIONS

1. Your assistant shows you the first draft of an entry form for a statewide video competition. The specifications for recording formats read as follows: "Only digital recording media will be accepted." Will you recommend any changes to this form? If so, why? If not, why not?

2. The CEO of a video production company asks you whether a Blu-ray disc can be played back on an HD DVD machine. What is your reply?

3. You are asked by the new dean of the College of Communications whether to invest in digital camcorders that use videotape as the recording media or camcorders with tapeless recording systems. Which type of system would you recommend? Why?

4. How does the recording codec influence the choice of recording media? Be specific.

5. The novice director tells you that you don't have to keep a field log because you will have to log the recorded clips anyway before editing. What is your reaction?

Nonlinear and Linear Editing

REVIEW OF KEY TERMS

Match each term with its appropriate definition by filling in the corresponding bubble.

1. VR log
2. edit master
3. insert editing
4. rough-cut
5. assemble editing

6. on-line editing
7. window dub
8. off-line editing
9. capture
10. pulse-count system

11. NLE system
12. EDL
13. linear editing system
14. SMPTE time code
15. digitize

A. A popular address code that marks each video frame with a specific number

A
○ ○ ○ ○ ○
1 2 3 4 5
○ ○ ○ ○ ○
6 7 8 9 10
○ ○ ○ ○ ○
11 12 13 14 15

B. Uses videotape as the recording medium

B
○ ○ ○ ○ ○
1 2 3 4 5
○ ○ ○ ○ ○
6 7 8 9 10
○ ○ ○ ○ ○
11 12 13 14 15

C. The transfer of a camcorder video to the hard drive of a computer

C
○ ○ ○ ○ ○
1 2 3 4 5
○ ○ ○ ○ ○
6 7 8 9 10
○ ○ ○ ○ ○
11 12 13 14 15

P A G E
T O T A L []

1. VR log	6. on-line editing	11. NLE system
2. edit master	7. window dub	12. EDL
3. insert editing	8. off-line editing	13. linear editing system
4. rough-cut	9. capture	14. SMPTE time code
5. assemble editing	10. pulse-count system	15. digitize

D. The media to which the final edit is exported

D ○ ○ ○ ○ ○
 1 2 3 4 5
 ○ ○ ○ ○ ○
 6 7 8 9 10
 ○ ○ ○ ○ ○
 11 12 13 14 15

E. The capture of shots in low resolution or an editing process that is not intended for producing an edit master

E ○ ○ ○ ○ ○
 1 2 3 4 5
 ○ ○ ○ ○ ○
 6 7 8 9 10
 ○ ○ ○ ○ ○
 11 12 13 14 15

F. Produces the final high-quality edit master tape in linear editing and recaptures selected shots in high-resolution in nonlinear editing

F ○ ○ ○ ○ ○
 1 2 3 4 5
 ○ ○ ○ ○ ○
 6 7 8 9 10
 ○ ○ ○ ○ ○
 11 12 13 14 15

G. Another name for a preliminary off-line edit

G ○ ○ ○ ○ ○
 1 2 3 4 5
 ○ ○ ○ ○ ○
 6 7 8 9 10
 ○ ○ ○ ○ ○
 11 12 13 14 15

H. Consists of edit-in and edit-out cues, expressed in time code numbers, and the nature of transitions between shots

H ○ ○ ○ ○ ○
 1 2 3 4 5
 ○ ○ ○ ○ ○
 6 7 8 9 10
 ○ ○ ○ ○ ○
 11 12 13 14 15

PAGE TOTAL []

I. The list of all takes and their in- and out-points used for editing; may have vector notations

I
○ ○ ○ ○ ○
1 2 3 4 5
○ ○ ○ ○ ○
6 7 8 9 10
○ ○ ○ ○ ○
11 12 13 14 15

J. An address code that uses the control track pulses to count elapsed time and frame numbers

J
○ ○ ○ ○ ○
1 2 3 4 5
○ ○ ○ ○ ○
6 7 8 9 10
○ ○ ○ ○ ○
11 12 13 14 15

K. A copy of the source tapes to a lower-quality tape format with the address code keyed into each frame

K
○ ○ ○ ○ ○
1 2 3 4 5
○ ○ ○ ○ ○
6 7 8 9 10
○ ○ ○ ○ ○
11 12 13 14 15

L. Adding shots on the edit master tape without the prior recording of a control track

L
○ ○ ○ ○ ○
1 2 3 4 5
○ ○ ○ ○ ○
6 7 8 9 10
○ ○ ○ ○ ○
11 12 13 14 15

M. The step that converts analog signals prior to capture

M
○ ○ ○ ○ ○
1 2 3 4 5
○ ○ ○ ○ ○
6 7 8 9 10
○ ○ ○ ○ ○
11 12 13 14 15

N. Produces highly stable edits; requires the prior laying of a control track on the edit master tape

N
○ ○ ○ ○ ○
1 2 3 4 5
○ ○ ○ ○ ○
6 7 8 9 10
○ ○ ○ ○ ○
11 12 13 14 15

P A G E
T O T A L [　　　　]

1. VR log	6. on-line editing	11. NLE system
2. edit master	7. window dub	12. EDL
3. insert editing	8. off-line editing	13. linear editing system
4. rough-cut	9. capture	14. SMPTE time code
5. assemble editing	10. pulse-count system	15. digitize

O. Editing system that allows random access of shots

O ◯ ◯ ◯ ◯ ◯
 1 2 3 4 5

 ◯ ◯ ◯ ◯ ◯
 6 7 8 9 10

 ◯ ◯ ◯ ◯ ◯
 11 12 13 14 15

PAGE TOTAL

SECTION TOTAL

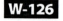

REVIEW OF NONLINEAR EDITING

Select the correct answers and fill in the bubbles with the corresponding numbers.

1. All nonlinear editing systems allow (16) *random access to a clip* (17) *no random access* (18) *random access only to specially marked clips.*

 1 ◯ ◯ ◯
 16 17 18

2. In nonlinear editing, the timeline refers to (19) *how long the clips are* (20) *video and audio tracks with their clips* (21) *the editor's production schedule.*

 2 ◯ ◯ ◯
 19 20 21

3. The three major components of an NLE system are (22) *source VTR, record VTR, source media* (23) *computer, editing software, source media* (24) *digitizer, high-speed computer, source media.*

 3 ◯ ◯ ◯
 22 23 24

4. The essential entry of a VR log is (25) *date of production* (26) *length of clip* (27) *time code in- and out-numbers.*

 4 ◯ ◯ ◯
 25 26 27

5. When engaged in nonlinear editing, you need to choose (28) *between insert and assemble editing* (29) *pulse count or time code mode* (30) *a specific codex.*

 5 ◯ ◯ ◯
 28 29 30

P A G E
T O T A L

6. Fill in the bubbles whose numbers correspond with the appropriate features of the generic nonlinear editing interface as shown in the following figure:

Herbert Zettl

a. time line

6a ○ ○ ○ ○
31 32 33 34
○ ○ ○ ○
35 36 37 38

b. playhead and scrubber bar

6b ○ ○ ○ ○
31 32 33 34
○ ○ ○ ○
35 36 37 38

c. video track

6c ○ ○ ○ ○
31 32 33 34
○ ○ ○ ○
35 36 37 38

d. audio track 1

6d ○ ○ ○ ○
31 32 33 34
○ ○ ○ ○
35 36 37 38

e. audio track 2

6e ○ ○ ○ ○
31 32 33 34
○ ○ ○ ○
35 36 37 38

PAGE
TOTAL

© 2013 Cengage Learning

f. project panel

6f ◯ ◯ ◯ ◯
31 32 33 34

◯ ◯ ◯ ◯
35 36 37 38

g. record monitor

6g ◯ ◯ ◯ ◯
31 32 33 34

◯ ◯ ◯ ◯
35 36 37 38

h. source monitor

6h ◯ ◯ ◯ ◯
31 32 33 34

◯ ◯ ◯ ◯
35 36 37 38

P A G E
T O T A L []

SECTION
TOTAL []

CHAPTER 12 NONLINEAR AND LINEAR EDITING

REVIEW OF LINEAR EDITING

Select the correct answers and fill in the bubbles with the corresponding numbers.

1. When doing assemble editing, you (39) *must replay the control track on the edit master tape before editing* (40) *stripe all source tapes with a control track* (41) *simply copy the selected shots onto the edit master tape.*

2. When editing video and audio separately with a linear system, you need to use (42) *assemble* (43) *audio* (44) *insert* editing.

3. Compared with the time code system, the pulse-count system is (45) *more accurate* (46) *less accurate* (47) *equally accurate* in locating a specific frame.

4. When using a normal single-source linear editing system, you can perform (48) *cuts and dissolves* (49) *cuts and wipes* (50) *cuts only.*

5. Linear systems (51) *allow* (52) *do not allow* (53) *allow only when digitized* random access to the source material.

6. Fill in the bubbles whose numbers correspond with the numbers identifying EDL mistakes in the following figure.

IN	OUT	
01 : 17 : 28 : 29	01 : 17 : 28 : 45	54
01 : 17 : 30 : 15	01 : 17 : 45 : 01	55
01 : 19 : 15 : 29	01 : 19 : 14 : 07	56
01 : 21 : 65 : 33	01 : 32 : 59 : 29	57
02 : 17 : 28 : 15	02 : 18 : 37 : 06	58
02 : 17 : 29 : 16	01 : 18 : 45 : 29	59

1 ○ 39 ○ 40 ○ 41

2 ○ 42 ○ 43 ○ 44

3 ○ 45 ○ 46 ○ 47

4 ○ 48 ○ 49 ○ 50

5 ○ 51 ○ 52 ○ 53

6 ○ 54 ○ 55 ○ 56
 ○ 57 ○ 58 ○ 59

SECTION TOTAL []

REVIEW QUIZ

*Mark the following statements as true or false by filling in the bubbles in the **T** (for true) or **F** (for false) column.*

		T	F
1.	The basic principle of nonlinear editing is file management rather than tape copying.	**1** ○ 60	○ 61
2.	The expanded linear editing system needs at least two source VTRs.	**2** ○ 62	○ 63
3.	The pulse-count system marks each frame with a unique address.	**3** ○ 64	○ 65
4.	Time code must be recorded with the actual production to achieve a continuous frame address.	**4** ○ 66	○ 67
5.	On a linear system, you must use insert editing to split audio and video.	**5** ○ 68	○ 69
6.	Once the source tapes are captured, nonlinear editing systems do not use source VTRs.	**6** ○ 70	○ 71
7.	NLE systems allow random access to pictures and sound.	**7** ○ 72	○ 73
8.	An EDL is necessary only if you do nonlinear editing.	**8** ○ 74	○ 75
9.	The SMPTE time code marks each frame with a unique address.	**9** ○ 76	○ 77
10.	A window dub keys a unique time code address over each frame.	**10** ○ 78	○ 79
11.	Ordinarily, off-line editing does not produce the final edit master tape.	**11** ○ 80	○ 81
12.	All analog source tapes must be digitized before audio and video information can be stored on the NLE hard drive.	**12** ○ 82	○ 83
13.	Nonlinear systems do not need a time code.	**13** ○ 84	○ 85
14.	You don't need two source VTRs to create a dissolve with an NLE system.	**14** ○ 86	○ 87
15.	In nonlinear editing you must use insert editing when replacing a shot in an edit master tape.	**15** ○ 88	○ 89
16.	In nonlinear editing, the source media video as well as the audio must be stored on a computer storage device.	**16** ○ 90	○ 91

SECTION TOTAL

PROBLEM-SOLVING APPLICATIONS

1. You are told to skip the off-line editing step because the nonlinear editing system will produce a high-quality edit master anyway. What is your comment?

2. The director is not concerned about continuity or cutaways during the shooting phase because the nonlinear editing system makes it easy to fix continuity problems. What is your reaction? Be specific.

3. You are told that you can skip making a window dub when using an NLE system because each frame will show a time code readout on the computer screen anyhow. What is your reaction?

4. The editor of the daily *Noon News* show tells you not to bother with switching to the audio waveform because she always edits sound by what she hears rather than by looking at the waveform. Her complaint is that the audio waveforms "muddle the timeline." What is your reaction? Be specific.

5. The same editor questions your need for high-end editing software (such as Final Cut Pro) and says that less complex programs, such as iMovie, are perfectly adequate if all you do is a cuts-only assembly of parts of the daily company news show. What is your reaction?

Editing Principles

REVIEW OF KEY TERMS

Match each term with its appropriate definition by filling in the corresponding bubble.

1. vector line
2. jump cut
3. diverging vectors
4. jogging

5. continuing vectors
6. complexity editing
7. cutaway

8. continuity editing
9. mental map
10. converging vectors

A. An imaginary line created by extending converging index vectors, or the direction of a motion vector

A ○ ○ ○ ○ ○
 1 2 3 4 5
 ○ ○ ○ ○ ○
 6 7 8 9 10

B. A shot that is used to intercut between two shots to improve continuity

B ○ ○ ○ ○ ○
 1 2 3 4 5
 ○ ○ ○ ○ ○
 6 7 8 9 10

C. Graphic vectors that extend each other, or index and motion vectors pointing and moving in the same direction

C ○ ○ ○ ○ ○
 1 2 3 4 5
 ○ ○ ○ ○ ○
 6 7 8 9 10

D. Index and motion vectors that point toward each other

D ○ ○ ○ ○ ○
 1 2 3 4 5
 ○ ○ ○ ○ ○
 6 7 8 9 10

PAGE
TOTAL []

1. **vector line**	5. **continuing vectors**	8. **continuity editing**
2. **jump cut**	6. **complexity editing**	9. **mental map**
3. **diverging vectors**	7. **cutaway**	10. **converging vectors**
4. **jogging**		

E. Tells us where things are or are supposed to be on- and off-screen

E ○ ○ ○ ○ ○
 1 2 3 4 5
 ○ ○ ○ ○ ○
 6 7 8 9 10

F. The building of an intensified screen event from carefully selected and juxtaposed shots

F ○ ○ ○ ○ ○
 1 2 3 4 5
 ○ ○ ○ ○ ○
 6 7 8 9 10

G. Index and motion vectors that point away from each other

G ○ ○ ○ ○ ○
 1 2 3 4 5
 ○ ○ ○ ○ ○
 6 7 8 9 10

H. The assembly of shots to ensure a seamless shot sequence

H ○ ○ ○ ○ ○
 1 2 3 4 5
 ○ ○ ○ ○ ○
 6 7 8 9 10

I. Frame-by-frame advancement of videotape, resulting in jerky motion

I ○ ○ ○ ○ ○
 1 2 3 4 5
 ○ ○ ○ ○ ○
 6 7 8 9 10

J. An image that jerks slightly from one screen position to another in two consecutive shots

J ○ ○ ○ ○ ○
 1 2 3 4 5
 ○ ○ ○ ○ ○
 6 7 8 9 10

PAGE TOTAL

SECTION TOTAL

REVIEW OF AESTHETIC PRINCIPLES
OF CONTINUITY EDITING

Select the correct answers and fill in the bubbles with the corresponding numbers.

1. In continuity editing you are primarily concerned with maintaining (11) *story continuity* (12) *schedule efficiency* (13) *vector continuity.*

 1 ◯ 11 ◯ 12 ◯ 13

2. Vectors indicate (14) *a direction* (15) *an edit command* (16) *a specific address code.*

 2 ◯ 14 ◯ 15 ◯ 16

3. To preserve index vector continuity, you (17) *must cross the vector line with cameras* (18) *should not cross the vector line with cameras* (19) *should ignore the vector line in adjacent shots.*

 3 ◯ 17 ◯ 18 ◯ 19

4. A jump cut means that the subject is (20) *jumping up and down* (21) *causing the shots to break up at the edit point* (22) *perceived as abruptly changing from one screen position to the next.*

 4 ◯ 20 ◯ 21 ◯ 22

5. To preserve motion vector continuity, you (23) *must cross the vector line with cameras* (24) *should not cross the vector line with cameras* (25) *should ignore the vector line in adjacent shots.*

 5 ◯ 23 ◯ 24 ◯ 25

6. The mental map includes (26) *only on-screen positions and directions* (27) *only off-screen positions and directions* (28) *both on- and off-screen positions and directions.*

 6 ◯ 26 ◯ 27 ◯ 28

7. To preserve graphic vector continuity, observing the vector line is (29) *essential* (30) *recommended* (31) *irrelevant.*

 7 ◯ 29 ◯ 30 ◯ 31

8. In the following figures, select the camera that is in the *wrong* place for continuity editing and fill in the corresponding bubble. Draw the principal vector line on all the figures (**a** through **d**).

 a. cutting from speaker to audience

 8a ◯ 32 ◯ 33 ◯ 34

b. cutting from camera 1 (35) to different points of view of the bride and groom during a wedding

8b ○ 35 ○ 36 ○ 37

35

36

37

c. over-the-shoulder shots of person A and person B

8c ○ 38 ○ 39 ○ 40

38

A

B

39 40

d. cutting from long shots to close-ups during car race

8d ○ 41 ○ 42 ○ 43

41 42

43

PAGE TOTAL

9. For each of the following storyboard pairs, indicate whether the shots (44) *can* (45) *cannot* be edited together to form converging index vectors.

a.

9a ◯ ◯
 44 45

b.

9b ◯ ◯
 44 45

c.

9c ◯ ◯
 44 45

d.

9d ◯ ◯
 44 45

PAGE TOTAL ☐

10. Cutting together the two shots shown below will result in (46) *diverging vectors* (47) *a jump cut* (48) *reversal of screen direction.*

Edward Aiona

Edward Aiona

REVIEW QUIZ

*Mark the following statements as true or false by filling in the bubbles in the **T** (for true) or
F (for false) column.*

		T	F
1.	When crossing the vector line during over-the-shoulder shooting, the talent will switch screen positions.	**1** ○ 49	○ 50
2.	Complexity editing requires a much stricter observance of the vector line principle than does continuity editing.	**2** ○ 51	○ 52
3.	Motion vectors cannot converge in a single shot.	**3** ○ 53	○ 54
4.	Postproduction editing is done primarily to fix production mistakes.	**4** ○ 55	○ 56
5.	Z-axis index vectors can be converging or diverging, depending on context.	**5** ○ 57	○ 58
6.	The primary function of complexity editing is to maintain the viewer's mental map.	**6** ○ 59	○ 60
7.	Motion vectors can be continuing or converging but not diverging.	**7** ○ 61	○ 62
8.	The mental map includes on-screen as well as off-screen positions.	**8** ○ 63	○ 64
9.	In complexity editing, a jump cut can be used to intensify the event.	**9** ○ 65	○ 66
10.	The vector line is especially relevant for preserving screen positions and index and motion vector continuity.	**10** ○ 67	○ 68
11.	The mental map is especially important when editing for continuity.	**11** ○ 69	○ 70
12.	When two cameras are close together shooting an oncoming car, they can cross the vector line.	**12** ○ 71	○ 72

SECTION
TOTAL []

PROBLEM-SOLVING APPLICATIONS

1. The new production intern suggests that you cover the New Year's parade by placing cameras exactly opposite each other on both sides of the street. How would you respond to the intern?

2. The host mispronounces the name of the guest during the video-recording of an interview. The director opts for going on rather than doing the opening again because "we can fix it in post." Do you agree with the director's decision? If so, why? If not, why not?

3. The director of a cable company production group tells you not to worry about what happens in off-screen space when editing because the "viewer" will not see what is going on in off-screen space anyway. What is your response?

4. A retired, highly experienced film director tells you to avoid jump cuts at all costs. What is your reaction?

5. When you want to cross the vector line with the camera to intensify a scene, the producer tells you that this is an absolute no-no. How would you justify "crossing the line"?

6. When watching a panel discussion, you notice that the index vectors of the host and the guests all point in the same screen-left direction. The director tells you that the viewers will know who's who, regardless of where the vectors point. What is your reaction? Be specific.

7. The producer tells you that shots that show the talent looking directly into the camera are always good because they will preserve shot continuity regardless of whether the following shots show the talent looking screen-left or screen-right. Do you agree with the producer? If so, why? If not, why not?

8. The EFP camera operator tells you not to worry about recording any cutaways because he has plenty of shots in his ESS file that can be used as cutaways. What is your reaction?

PART

V

Production Environment: Studio, Field, and Synthetic

Production Environment: Studio

REVIEW OF KEY TERMS

Match each term with its appropriate definition by filling in the corresponding bubble.

1. cyc
2. PL
3. SA
4. intercom
5. studio control room
6. monitors
7. master control
8. flat
9. props
10. floor plan
11. IFB

A. High-quality video displays used in the studio and control rooms; cannot receive broadcast signals

A ○ ○ ○ ○
 1 2 3 4
 ○ ○ ○ ○
 5 6 7 8
 ○ ○ ○
 9 10 11

B. Communication system for all production and engineering personnel involved in the production of a show; includes IFB, PL, SA, and cellular telephones

B ○ ○ ○ ○
 1 2 3 4
 ○ ○ ○ ○
 5 6 7 8
 ○ ○ ○
 9 10 11

C. Furniture and other objects used by talent and for set decoration

C ○ ○ ○ ○
 1 2 3 4
 ○ ○ ○ ○
 5 6 7 8
 ○ ○ ○
 9 10 11

PAGE TOTAL ☐

1. cyc	5. studio control room	9. props
2. PL	6. monitors	10. floor plan
3. SA	7. master control	11. IFB
4. intercom	8. flat	

D. Controls the program input, storage, and retrieval of on-the-air telecasts; also oversees technical quality of all program material

D
○ ○ ○ ○
1 2 3 4
○ ○ ○ ○
5 6 7 8
○ ○ ○
9 10 11

E. A diagram of scenery, properties, and set dressings drawn on a grid

E
○ ○ ○ ○
1 2 3 4
○ ○ ○ ○
5 6 7 8
○ ○ ○
9 10 11

F. A U-shaped continuous piece of canvas or muslin for backing of scenery and action

F
○ ○ ○ ○
1 2 3 4
○ ○ ○ ○
5 6 7 8
○ ○ ○
9 10 11

G. Piece of standing scenery used as background or to simulate the wall of a room

G
○ ○ ○ ○
1 2 3 4
○ ○ ○ ○
5 6 7 8
○ ○ ○
9 10 11

H. Major intercommunication device in video production studios

H
○ ○ ○ ○
1 2 3 4
○ ○ ○ ○
5 6 7 8
○ ○ ○
9 10 11

PAGE TOTAL ☐

I. Allows the director to give the talent instructions while the talent is on the air

I ○ ○ ○ ○
 1 2 3 4
 ○ ○ ○ ○
 5 6 7 8
 ○ ○ ○
 9 10 11

J. A room adjacent to the studio in which the director, the producer, various production assistants, the TD, the audio engineer, and sometimes the LD perform their various production functions

J ○ ○ ○ ○
 1 2 3 4
 ○ ○ ○ ○
 5 6 7 8
 ○ ○ ○
 9 10 11

K. A public-address loudspeaker system from the control room to the studio

K ○ ○ ○ ○
 1 2 3 4
 ○ ○ ○ ○
 5 6 7 8
 ○ ○ ○
 9 10 11

PAGE
TOTAL []

SECTION
TOTAL []

REVIEW OF VIDEO PRODUCTION STUDIO AND MAJOR INSTALLATIONS

Select the correct answers and fill in the bubbles with the corresponding numbers.

1. The major function of a cyc is to serve as a (12) *chroma-key area* (13) *continuous background for scenery* (14) *sound-deadening device.*

 1 ○ ○ ○
 12 13 14

2. The switcher should be located adjacent to the (15) *LD's* (16) *director's* (17) *producer's* (18) *CG operator's* position.

 2 ○ ○ ○ ○
 15 16 17 18

3. Even for small studios, the minimum ceiling height is (19) *12 feet* (20) *14 feet* (21) *18 feet.*

 3 ○ ○ ○
 19 20 21

4. You need a separate video monitor (22) *for each video switcher input* (23) *for preset and line video only* (24) *for remote inputs only.*

 4 ○ ○ ○
 22 23 24

5. Assuming that the off-the-air receiver (AIR) shows the correct CG image, which monitors display the wrong picture? *(Multiple answers are possible.)*

 (25) *remote-2 monitor* (32) *C-1 monitor*

 (26) *C-3 monitor* (33) *C-2 monitor*

 (27) *VR-3 monitor* (34) *VR-2 monitor*

 (28) *remote-1 monitor* (35) *line monitor*

 (29) *electronic still store monitor* (36) *preview monitor*

 (30) *character generator monitor* (37) *VR-1 monitor*

 (31) *effects monitor*

5 ○ ○ ○ ○ ○
 25 26 27 28 29

 ○ ○ ○ ○ ○
 30 31 32 33 34

 ○ ○ ○
 35 36 37

Edward Aiona

SECTION TOTAL []

REVIEW OF SCENERY, PROPERTIES, AND SCENIC DESIGN

1. Fill in the bubbles whose numbers correspond with the numbers identifying the various set pieces in the following figure.

| 38 | 39 | 40 | 41 | 42 | 43 |

a. screen

1a ○ 38 ○ 39 ○ 40
 ○ 41 ○ 42 ○ 43

b. pillar

1b ○ 38 ○ 39 ○ 40
 ○ 41 ○ 42 ○ 43

c. square pillar

1c ○ 38 ○ 39 ○ 40
 ○ 41 ○ 42 ○ 43

d. pylon

1d ○ 38 ○ 39 ○ 40
 ○ 41 ○ 42 ○ 43

e. periaktos

1e ○ 38 ○ 39 ○ 40
 ○ 41 ○ 42 ○ 43

f. sweep

1f ○ 38 ○ 39 ○ 40
 ○ 41 ○ 42 ○ 43

PAGE TOTAL []

2. From the rough floor plans shown below, select the one that most closely matches the simple sets shown on the facing page and fill in the corresponding bubbles. *(Note that there are floor plans that do not match any of the set photos.)*

44

45

46

47

48

49

50

51

52

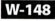

a.

b.

c.

d.

e.

f.

Herbert Zettl

2a ○ ○ ○ ○ ○
 44 45 46 47 48
 ○ ○ ○ ○
 49 50 51 52

2b ○ ○ ○ ○ ○
 44 45 46 47 48
 ○ ○ ○ ○
 49 50 51 52

2c ○ ○ ○ ○ ○
 44 45 46 47 48
 ○ ○ ○ ○
 49 50 51 52

2d ○ ○ ○ ○ ○
 44 45 46 47 48
 ○ ○ ○ ○
 49 50 51 52

2e ○ ○ ○ ○ ○
 44 45 46 47 48
 ○ ○ ○ ○
 49 50 51 52

2f ○ ○ ○ ○ ○
 44 45 46 47 48
 ○ ○ ○ ○
 49 50 51 52

PAGE
TOTAL []

CHAPTER 14 *PRODUCTION ENVIRONMENT: STUDIO*

Select the correct answers and fill in the bubbles with the corresponding numbers.

3. The standard backgrounds used to simulate interior and exterior walls are called (53) *cycs* (54) *drops* (55) *flats.*

3 ◯ ◯ ◯
 53 54 55

4. A bookcase, the books in it, and the chair next to it are all part of (56) *set furniture* (57) *set decoration* (58) *properties.*

4 ◯ ◯ ◯
 56 57 58

5. The usual height for standard set units is (59) *7 feet* (60) *14 feet* (61) *10 feet.* For low-ceiling studios, it is (62) *8 feet* (63) *6 feet* (64) *12 feet.* **(Fill in two bubbles.)**

5 ◯ ◯ ◯
 59 60 61

◯ ◯ ◯
62 63 64

6. To elevate scenery, properties, or action areas, we use (65) *periaktoi* (66) *pylons* (67) *platforms.*

6 ◯ ◯ ◯
 65 66 67

7. The desk for the news anchor is considered a (68) *set prop* (69) *hand prop* (70) *set dressing.*

7 ◯ ◯ ◯
 68 69 70

8. The continuous piece of canvas or muslin stretched along two, three, or even all four studio walls to form a uniform background is referred to as (71) *a drop* (72) *canvas backing* (73) *a cyclorama.*

8 ◯ ◯ ◯
 71 72 73

9. A ground row is usually built into the (74) *control room* (75) *hardwall cyc* (76) *prop area.*

9 ◯ ◯ ◯
 74 75 76

10. Scenic pieces that can be used in a variety of configurations are called (77) *set modules* (78) *hardwall flats* (79) *set dressings.*

10 ◯ ◯ ◯
 77 78 79

11. The painting at the back of an interview set is a (80) *set prop* (81) *hand prop* (82) *set dressing.*

11 ◯ ◯ ◯
 80 81 82

PAGE TOTAL []

SECTION TOTAL []

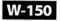

REVIEW QUIZ

*Mark the following statements as true or false by filling in the bubbles in the **T** (for true) or*
***F** (for false) column.*

		T	F
1.	Seamless paper and a cyc fulfill similar functions.	**1** ○ 83	○ 84
2.	The switcher must be located right next to the producer's position.	**2** ○ 85	○ 86
3.	The control room must be equipped with speakers that carry the line-out audio signal.	**3** ○ 87	○ 88
4.	The sound mixing console must be located as close to the director as possible.	**4** ○ 89	○ 90
5.	A well-functioning SA system makes a PL unnecessary.	**5** ○ 91	○ 92
6.	An accurate control room clock makes the use of a stopwatch unnecessary.	**6** ○ 93	○ 94
7.	A monitor is identical to a television set except that it has a sharper picture.	**7** ○ 95	○ 96
8.	The program objective has a great influence on the set design.	**8** ○ 97	○ 98
9.	In a scenic context, jacks are electrical outlets for prop lamps.	**9** ○ 99	○ 100
10.	All active furniture should be placed at least 6 to 8 feet from the background scenery.	**10** ○ 101	○ 102
11.	Wagons can be used as platforms.	**11** ○ 103	○ 104
12.	A small studio does not need a smooth floor because zoom lenses make dollying unnecessary.	**12** ○ 105	○ 106
13.	All professional production sets, such as a news set, are constructed with hardwall flats.	**13** ○ 107	○ 108
14.	The preview (or preset) and line monitors should ideally be side-by-side in the control room.	**14** ○ 109	○ 110
15.	In many video productions, props and set dressings are more important than the background flats for indicating a certain style.	**15** ○ 111	○ 112
16.	A lashline is a convenient means of connecting softwall flats.	**16** ○ 113	○ 114
17.	All professional directors direct their live shows from master control.	**17** ○ 115	○ 116

SECTION TOTAL ☐

PROBLEM-SOLVING APPLICATIONS

1. You are asked by the new art professor about the feasibility of converting a classroom into a small video production studio. The classroom has no windows, normal doors, a 10-foot ceiling with standard fluorescent lighting, and a wood floor. What would you tell the professor? Be specific.

2. You are asked by the company president why you need so many monitors in the control room. She tells you that she had consulted an electronics engineer, who told her that there are switching devices that let you preview multiple video sources on a single monitor. She quotes the engineer as saying that all you really need are two monitors—a preview and a line monitor. How, if at all, would you defend a multimonitor stack in the control room?

3. You are to evaluate the preliminary design for a new control room (see illustration below). What, if any, changes would you recommend? Why?

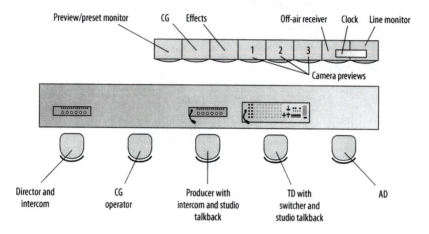

4. Using one of the forms at the back of this workbook, draw a floor plan for a weekly interview show dealing with the art and media scene in your city. The host will interview guests from theater, music, radio, and television. Include a detailed prop list.

5. Draw a floor plan for a morning news set. The anchors are a woman and a man, and the news content is geared more toward local gossip than international politics.

Course No. _____ Date _____ Name _____

Production Environment: Field and Synthetic

REVIEW OF KEY TERMS

Match each term with its appropriate definition by filling in the corresponding bubble.

1. big remote
2. remote truck
3. uplink truck
4. field production

5. contact person
6. EFP
7. remote survey

8. ENG
9. virtual reality
10. synthetic environment

A. The use of portable camcorders, lights, and sound equipment for the production of unplanned daily news events; usually done for live transmission or immediate postproduction

A ○ ○ ○ ○ ○
 1 2 3 4 5
 ○ ○ ○ ○ ○
 6 7 8 9 10

B. Computer-simulated environment with which the user can interact

B ○ ○ ○ ○ ○
 1 2 3 4 5
 ○ ○ ○ ○ ○
 6 7 8 9 10

C. The vehicle that carries the control room, audio control, VR section, video control section, and transmission equipment

C ○ ○ ○ ○ ○
 1 2 3 4 5
 ○ ○ ○ ○ ○
 6 7 8 9 10

D. Video production done outside the studio that is usually shot for postproduction (not live)

D ○ ○ ○ ○ ○
 1 2 3 4 5
 ○ ○ ○ ○ ○
 6 7 8 9 10

PAGE TOTAL []

 W-153

1. big remote	5. contact person	8. ENG		
2. remote truck	6. EFP	9. virtual reality		
3. uplink truck	7. remote survey	10. synthetic environment		
4. field production				

E. A production of a large, scheduled event outside the studio for live transmission or recorded live

E ○1 ○2 ○3 ○4 ○5
 ○6 ○7 ○8 ○9 ○10

F. Small vehicle that sends video and audio signals to a satellite

F ○1 ○2 ○3 ○4 ○5
 ○6 ○7 ○8 ○9 ○10

G. An inspection of the remote location by key production and engineering personnel so that they can plan for the setup and the use of production equipment

G ○1 ○2 ○3 ○4 ○5
 ○6 ○7 ○8 ○9 ○10

H. Electronically generated settings, either through chroma key or computer

H ○1 ○2 ○3 ○4 ○5
 ○6 ○7 ○8 ○9 ○10

I. Any video production that happens outside the studio

I ○1 ○2 ○3 ○4 ○5
 ○6 ○7 ○8 ○9 ○10

J. An individual who is familiar with and who can facilitate access to the remote location and the key people

J ○1 ○2 ○3 ○4 ○5
 ○6 ○7 ○8 ○9 ○10

PAGE TOTAL []

SECTION TOTAL []

REVIEW OF ENG AND EFP

Select the correct answers and fill in the bubbles with the corresponding numbers.

1. When interviewing a fire chief on the fire line, your major audio concern is (11) *wind* (12) *traffic noise* (13) *ambient sounds.*

 1 ○ 11 ○ 12 ○ 13

2. An equipment checklist is least important for (14) *big remotes* (15) *EFP* (16) *ENG.*

 2 ○ 14 ○ 15 ○ 16

3. The one field production that functions most of the time without a remote survey is (17) *ENG* (18) *EFP* (19) *big remotes.*

 3 ○ 17 ○ 18 ○ 19

4. When using a computer-generated background for live action, you must watch that the (20) *motion vectors* (21) *attached and cast shadows* (22) *colors* match between foreground and background.

 4 ○ 20 ○ 21 ○ 22

5. When surveying a room for an EFP, one of the important items to check is the (23) *location of doors* (24) *ceiling height* (25) *location of windows.*

 5 ○ 23 ○ 24 ○ 25

6. A functioning PL intercom system is essential for (26) *big remotes* (27) *EFP* (28) *ENG.*

 6 ○ 26 ○ 27 ○ 28

7. When the reporter uses an external hand or lavalier mic, you (29) *should* (30) *should not* open the camera mic simultaneously.

 7 ○ 29 ○ 30

8. The field production least likely to use signal transmission equipment is (31) *EFP* (32) *ENG* (33) *big remotes.*

 8 ○ 31 ○ 32 ○ 33

9. One of the important preproduction activities for EFP is (34) *procuring RCUs for the cameras* (35) *consulting with the art director* (36) *conducting a remote survey.*

 9 ○ 34 ○ 35 ○ 36

10. Whenever possible you should white-balance your camcorder (37) *every time you enter a new lighting environment* (38) *before going out for a shoot* (39) *only when it gets dark.*

 10 ○ 37 ○ 38 ○ 39

11. In EFP the best way to light indoor activities is to (40) *use a few high-powered spotlights* (41) *use several low-powered floodlights* (42) *place the action in front of a window.*

 11 ○ 40 ○ 41 ○ 42

P A G E
T O T A L [＿＿＿＿]

12. Analyze the following location sketch and select the major production hazards from the list below. Fill in the bubbles with the corresponding numbers. *(**Multiple answers are possible.**)*

(43) *little room for cross shooting*

(44) *plants interfering with good composition*

(45) *window causing lighting problems*

(46) *no room for VRs*

(47) *matching color temperatures, if 3,200K fill lights are used*

(48) *computer interfering with video signal*

12 ○ ○ ○
 43 44 45
 ○ ○ ○
 46 47 48

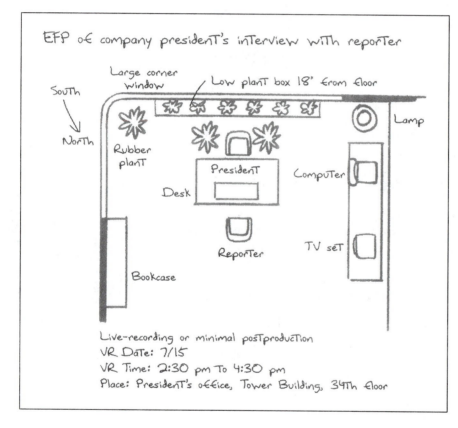

EFP of company president's interview with reporter

Large corner window — Low plant box 18" from floor

South / North

Rubber plant

President — Desk

Lamp

Computer

Reporter

TV set

Bookcase

Live-recording or minimal postproduction
VR Date: 7/15
VR Time: 2:30 pm To 4:30 pm
Place: President's office, Tower Building, 34Th floor

© 2013 Cengage Learning

*Evaluate the equipment checklists for the three electronic field productions described below.
Identify the **wrong equipment** or **items not needed** to take on-location and fill in the bubbles
with the corresponding numbers. (**Multiple answers are possible.**)*

13. Video-recorded interview of a media scholar in his hotel room for news item.

13 ○ ○ ○ ○ ○
 49 50 51 52 53
○ ○ ○ ○
54 55 56 57

CHECKLIST

(49) *digital camcorder*

(50) *VR*

(51) *portable lighting kit*

(52) *RCU*

(53) *lavalier mic*

(54) *portable audio mixer*

(55) *recording media*

(56) *batteries*

(57) *two preview monitors*

14. Live stand-up traffic report from downtown during early-afternoon rush hour.

14 ○ ○ ○ ○ ○
 58 59 60 61 62
○ ○ ○ ○
63 64 65 66

CHECKLIST

(58) *camera mic*

(59) *2 VRs*

(60) *digital camcorder*

(61) *hand mic*

(62) *3 portable lighting kits*

(63) *CG*

(64) *microwave transmission equipment*

(65) *IFB intercom*

(66) *audio recorder*

15. Live recording of a brief dance routine in front of city hall.

15 ○ ○ ○ ○ ○
 67 68 69 70 71
○ ○ ○ ○
72 73 74 75

CHECKLIST

(67) *3 ENG/EFP cameras*

(68) *6 shotgun mics*

(69) *ESS*

(70) *3 VRs*

(71) *3 RCUs and connecting cables*

(72) *large audio console*

(73) *PA audiotape playback system*

(74) *fishpoles for mics*

(75) *CG*

P A G E TOTAL	
SECTION TOTAL	

REVIEW QUIZ

Mark the following statements as true or false by filling in the bubbles in the **T** (for true) or **F** (for false) column.

		T	F
1.	A contact person is necessary for EFP and big remotes.	**1** ○ 76	○ 77
2.	An IFB intercom system is essential for successful EFP.	**2** ○ 78	○ 79
3.	The position of the sun is an important factor in surveys for outdoor remotes.	**3** ○ 80	○ 81
4.	Because in EFP the director can check the camera viewfinder, a playback monitor is not necessary.	**4** ○ 82	○ 83
5.	A well-equipped remote truck must contain a compact image control center.	**5** ○ 84	○ 85
6.	Remote surveys are especially important for ENG.	**6** ○ 86	○ 87
7.	A remote survey is important for the technical crew but not the nontechnical people.	**7** ○ 88	○ 89
8.	ENG and EFP require the same level of preproduction.	**8** ○ 90	○ 91
9.	A remote truck is usually powered by an external power source.	**9** ○ 92	○ 93
10.	All synthetic environments must originally be lens-generated.	**10** ○ 94	○ 95
11.	Keeping an accurate field log is especially important for a live remote pickup.	**11** ○ 96	○ 97
12.	There is no difference between a lens-generated and a computer-generated environment.	**12** ○ 98	○ 99
13.	Contrary to ENG, EFP does not require keeping accurate field logs.	**13** ○ 100	○ 101
14.	If possible, you should do the survey for an outdoor remote during the time the actual production will take place.	**14** ○ 102	○ 103
15.	A satellite uplink truck is essential for transmitting a live ENG pickup from a remote location.	**15** ○ 104	○ 105

SECTION TOTAL []

PROBLEM-SOLVING APPLICATIONS

1. To get a good overhead shot of a parade, you would like to place one of the cameras in the twentieth-floor window of a nearby hotel. The TD informs you that the hotel manager has nothing against your renting the room for the day and setting up the camera, but he will not allow any long cable runs either inside or outside the hotel. What would you suggest?

2. To be "on the cutting edge" with his employees, the new company president would like to speak to them from a fantasy landscape yet remain behind his familiar desk. Can you oblige the president's request? If so, how? If not, why not?

3. You are asked to help draw up specifications for a new remote truck for a college broadcasting department that specializes in telecasting all kinds of college sports. What questions should you ask before making a recommendation? Why?

4. The new PA is very upset about your failure to request an adequate PL system for the single-camera EFP in the university student union. What would you tell the PA? Why?

5. Conduct a detailed remote survey of two of the following events: a local school board meeting; a rock concert in a city park; a modern dance performance in front of city hall; an interview with a university president in his or her office; the gala opening of a new computer store; a wedding in a local church; a basketball game in a high-school or college gym.

PART

VI

Production Control:
Talent and Directing

Talent, Clothing, and Makeup

REVIEW OF KEY TERMS

Match each term with its appropriate definition by filling in the corresponding bubble.

1. foundation
2. talent
3. cue card

4. teleprompter
5. moiré effect
6. performer

7. blocking
8. IFB
9. actor

A. Carefully worked-out movement and actions of the talent and all mobile video equipment used in a scene

A ○ ○ ○ ○ ○
 1 2 3 4 5
 ○ ○ ○ ○
 6 7 8 9

B. A makeup base, normally done with water-soluble cake makeup or sprayed on

B ○ ○ ○ ○ ○
 1 2 3 4 5
 ○ ○ ○ ○
 6 7 8 9

C. A person who appears on-camera in nondramatic shows

C ○ ○ ○ ○ ○
 1 2 3 4 5
 ○ ○ ○ ○
 6 7 8 9

D. A prompting system that allows communication with talent while on the air

D ○ ○ ○ ○ ○
 1 2 3 4 5
 ○ ○ ○ ○
 6 7 8 9

PAGE TOTAL []

1. foundation	4. teleprompter	7. blocking
2. talent	5. moiré effect	8. IFB
3. cue card	6. performer	9. actor

E. Color vibrations that occur when narrow, contrasting stripes of a design interfere with the frequency of the scanning lines of the video system

E ○ ○ ○ ○ ○
 1 2 3 4 5
 ○ ○ ○ ○
 6 7 8 9

F. A large hand-lettered card that contains copy, usually held next to the camera lens by floor personnel

F ○ ○ ○ ○ ○
 1 2 3 4 5
 ○ ○ ○ ○
 6 7 8 9

G. Collective name for all performers and actors who appear regularly on television

G ○ ○ ○ ○ ○
 1 2 3 4 5
 ○ ○ ○ ○
 6 7 8 9

H. A person who appears on-camera in dramatic roles

H ○ ○ ○ ○ ○
 1 2 3 4 5
 ○ ○ ○ ○
 6 7 8 9

I. A device that projects the moving copy over the camera lens so that the talent can read it without losing eye contact with the viewer

I ○ ○ ○ ○ ○
 1 2 3 4 5
 ○ ○ ○ ○
 6 7 8 9

PAGE TOTAL

SECTION TOTAL

REVIEW OF PERFORMANCE TECHNIQUES

1. The following figures show various cues as given to the talent by the floor manager. From the list below, select the specific cue illustrated and fill in the bubble with the corresponding number.

(10) *wind up* (15) *standby*

(11) *5 minutes left* (16) *speed up*

(12) *15 seconds left* (17) *cue*

(13) *cut* (18) *30 seconds left*

(14) *stretch* (19) *on time*

a. pulls hands apart

b.

c.

d. rotates hand

1a ◯ ◯ ◯ ◯ ◯
 10 11 12 13 14
 ◯ ◯ ◯ ◯ ◯
 15 16 17 18 19

1b ◯ ◯ ◯ ◯ ◯
 10 11 12 13 14
 ◯ ◯ ◯ ◯ ◯
 15 16 17 18 19

1c ◯ ◯ ◯ ◯ ◯
 10 11 12 13 14
 ◯ ◯ ◯ ◯ ◯
 15 16 17 18 19

1d ◯ ◯ ◯ ◯ ◯
 10 11 12 13 14
 ◯ ◯ ◯ ◯ ◯
 15 16 17 18 19

PAGE TOTAL

(10) *wind up*
(11) *5 minutes left*
(12) *15 seconds left*
(13) *cut*
(14) *stretch*

(15) *standby*
(16) *speed up*
(17) *cue*
(18) *30 seconds left*
(19) *on time*

e.

f.

1e ○ ○ ○ ○ ○
 10 11 12 13 14
○ ○ ○ ○ ○
15 16 17 18 19

1f ○ ○ ○ ○ ○
 10 11 12 13 14
○ ○ ○ ○ ○
15 16 17 18 19

g. rotates hand with
extended index finger

h. pulls index finger
across throat

1g ○ ○ ○ ○ ○
 10 11 12 13 14
○ ○ ○ ○ ○
15 16 17 18 19

1h ○ ○ ○ ○ ○
 10 11 12 13 14
○ ○ ○ ○ ○
15 16 17 18 19

i.

j.

1i ○ ○ ○ ○ ○
 10 11 12 13 14
○ ○ ○ ○ ○
15 16 17 18 19

1j ○ ○ ○ ○ ○
 10 11 12 13 14
○ ○ ○ ○ ○
15 16 17 18 19

P A G E
T O T A L

2. The following figures show various cues as given to the talent by the floor manager. From the list below, select the specific cue illustrated and fill in the bubble with the corresponding number.

(20) *walk*

(21) *closer*

(22) *keep talking*

(23) *VR rolling*

(24) *closer to mic*

(25) *tone down*

(26) *speak up*

(27) *OK*

(28) *stop*

(29) *back*

a. fingers open and close like a bird beak

b.

2a ○ ○ ○ ○ ○
20 21 22 23 24
○ ○ ○ ○ ○
25 26 27 28 29

2b ○ ○ ○ ○ ○
20 21 22 23 24
○ ○ ○ ○ ○
25 26 27 28 29

c. pushes palms forward

d.

2c ○ ○ ○ ○ ○
20 21 22 23 24
○ ○ ○ ○ ○
25 26 27 28 29

2d ○ ○ ○ ○ ○
20 21 22 23 24
○ ○ ○ ○ ○
25 26 27 28 29

PAGE TOTAL []

(20) *walk*	(25) *tone down*
(21) *closer*	(26) *speak up*
(22) *keep talking*	(27) *OK*
(23) *VR rolling*	(28) *stop*
(24) *closer to mic*	(29) *back*

e.

f.

2e ○ ○ ○ ○ ○
 20 21 22 23 24
 ○ ○ ○ ○ ○
 25 26 27 28 29

2f ○ ○ ○ ○ ○
 20 21 22 23 24
 ○ ○ ○ ○ ○
 25 26 27 28 29

g. pulls hands toward body

h. moves fingers back and forth

2g ○ ○ ○ ○ ○
 20 21 22 23 24
 ○ ○ ○ ○ ○
 25 26 27 28 29

2h ○ ○ ○ ○ ○
 20 21 22 23 24
 ○ ○ ○ ○ ○
 25 26 27 28 29

i.

j.

2i ○ ○ ○ ○ ○
 20 21 22 23 24
 ○ ○ ○ ○ ○
 25 26 27 28 29

2j ○ ○ ○ ○ ○
 20 21 22 23 24
 ○ ○ ○ ○ ○
 25 26 27 28 29

PAGE TOTAL []

Select the correct answers and fill in the bubbles with the corresponding numbers.

3. When wearing a lavalier mic, you should (30) *increase your volume when the camera gets farther away from you* (31) *maintain your audio level regardless of how far the camera is away from you* (32) *speak more softly when the camera is relatively close to you.*

 3 ○ ○ ○
 30 31 32

4. When asked for an audio level, you should (33) *blow into the mic* (34) *count quickly to five* (35) *recite your opening remarks at on-air levels.*

 4 ○ ○ ○
 33 34 35

5. When you receive cues during the actual video-recording that are different from the rehearsed ones, you should (36) *execute the action as rehearsed* (37) *follow the floor manager's cues* (38) *check with the director.*

 5 ○ ○ ○
 36 37 38

6. From the list below, select the microphone most appropriate for the various performance and acting tasks and fill in the bubbles with the corresponding numbers.

 (39) *fishpole mic* (42) *stand mic*

 (40) *lavalier mic* (43) *hand mic*

 (41) *desk mics*

 a. Two actors doing a brief outdoor scene.

 6a ○ ○ ○ ○ ○
 39 40 41 42 43

 b. News anchor who remains seated throughout newscast.

 6b ○ ○ ○ ○ ○
 39 40 41 42 43

 c. Lead guitarist of a rock band who also sings and talks to the audience.

 6c ○ ○ ○ ○ ○
 39 40 41 42 43

 d. Moderating a panel discussion with six guests.

 6d ○ ○ ○ ○ ○
 39 40 41 42 43

 e. Interview with a celebrity at a busy airport ticket counter.

 6e ○ ○ ○ ○ ○
 39 40 41 42 43

7. If you do not use IFB during a studio production, you should take your opening cues from (44) *the camera operator* (45) *the tally lights* (46) *the floor manager.*

 7 ○ ○ ○
 44 45 46

8. For the talent the most accurate indicator of the camera's field of view is (47) *the relative distance between talent and camera* (48) *the floor manager's cues* (49) *the studio monitor.*

 8 ○ ○ ○
 47 48 49

9. When demonstrating a small object, you should (50) *move it slowly toward the camera* (51) *keep it as steady as possible or on the display table* (52) *hold it as close to the lens as possible.*

 9 ○ ○ ○
 50 51 52

PAGE
TOTAL ☐

SECTION
TOTAL ☐

10. Read the following copy into a mirror or video camera or, ideally, into a television camera with a teleprompter at least three times. Video-record your performances. Time your narration with a stopwatch and try to match your times with the ones given in subsequent readings.

a. news copy

```
Package: Australia Earth Mover

TALENT O/C         IN SOUTHERN AUSTRALIA,
(ON CAMERA)        ENGINEERS ARE RAVING ABOUT A NEW
                   DEVELOPMENT...A GIANT EARTH MOVER
                   THAT HAS NO WHEELS. CHIEF ENGINEER
                   FRED STEINER SAYS HE OBSERVED HOW A
                   CENTIPEDE TRAVELS AND SIMPLY COPIED
                   ITS MOVEMENTS.

SERVER FILE
0120
VO                 THE MANY LEGS ENABLE THE MACHINE TO
                   NEGOTIATE DITCHES, BUSHES, AND EVEN
                   GOOD-SIZED BOULDERS WITHOUT SPILLING
                   ITS LOAD OR TIPPING OVER.

                   JOHN HEWITT TALKED TO THE DRIVER...OR
                   RIDER?...OF THE MONSTER CENTIPEDE...

SERVER FILE
0121
SOS
(SOUND ON SOURCE)
1:45
```

Given time: 29 seconds

Your first reading: _____ seconds

Your second reading: _____ seconds

Your third reading: _____ seconds

b. introduction to a weekly sports show

```
VIDEO              AUDIO

STANDARD
OPENING
SERVER FILE
SP 772

WALTER O/C         Hi, I'm Alex Walter. Welcome
(ON CAMERA)        to Sports at Four. Today we have
                   with us the world's most prominent
                   and amazing mountain climber--

CU MESSNER         Reinhold Messner. He will talk to us
                   about how he prepared for his extreme
                   climbs and what he thought and felt
CG: EVEREST        when he climbed--often alone--the big
                   walls of the world's highest peaks.

WALTER O/C         He has brought with him some of the
                   best mountain-climbing footage I have
                   ever seen--and he will share it with
                   us. We will also see where Reinhold
                   lives and what he does now. All coming
                   up next on Sports at Four.

----------------------------------------------------
SERVER FILE        COMMERCIAL #1
SP 844
----------------------------------------------------
```

Given time: 35 seconds

Your first reading: _____ seconds

Your second reading: _____ seconds

Your third reading: _____ seconds

c. commercial *(Note that this commercial represents a high-pressure pitch and requires fast reading.)*

VIDEO	AUDIO
CHROMA KEY ESS 64: CARS	
CU OF BAKER ZOOM OUT TO MS	Hi, I'm Tom Baker of Baker Chevrolet to talk to you about automobile leasing. It can mean lower monthly payments, and it lets you keep that down payment for other things you need.
CUT TO CG: LOWER MONTHLY PAYMENTS	
CUT TO ESS 65: CAR 1 ESS 66: CAR 2	For example, you can lease this brand-new beauty for only 300 dollars per month or this fuel-efficient luxury car for only 499 dollars per month--and we'll even buy your old car and give you the cash!
CUT TO CU OF BAKER + CHROMA KEY ESS 64	So come on down and drive away in your dream car.
CUT TO CG SIGNATURE	It's only at Baker Chevrolet in Virginia City. Come in right now and save!

Given time: 30 seconds

Your first reading: _____ seconds

Your second reading: _____ seconds

Your third reading: _____ seconds

REVIEW OF PERFORMANCE AND ACTING TECHNIQUES

Select the correct answers and fill in the bubbles with the corresponding numbers.

1. When substituting for the regular host of a studio talk show for the first time, you should (53) *discuss the lighting with the LD* (54) *verify the specific cues with the floor manager* (55) *test the quality of the microphone used.*

 1 ○ ○ ○
 53 54 55

2. When you can't read the teleprompter copy well enough, you should (56) *have the camera move closer to you* (57) *ask the operator to slow down the scroll* (58) *have the text made bigger.*

 2 ○ ○ ○
 56 57 58

3. When you receive the floor manager's time cue, you should (59) *verify it by glancing at the clock* (60) *give the floor manager a brief nod to acknowledge the cue* (61) *do nothing but adjust your performance to the remaining time.*

 3 ○ ○ ○
 59 60 61

4. To establish eye contact with the viewer, you need to pretend to (62) *look through the lens* (63) *converse with the floor manager* (64) *converse with the camera operator.*

 4 ○ ○ ○
 62 63 64

5. When doing an O/S or cross-shooting scene, you must adjust your blocking so that you see (65) *the camera lens* (66) *the floor manager* (67) *the key light.*

 5 ○ ○ ○
 65 66 67

6. To keep eye contact with the viewer when cameras are switched on you, you need to (68) *follow the tally lights* (69) *follow the floor manager's cues* (70) *listen to the producer's IFB cues.*

 6 ○ ○ ○
 68 69 70

7. Pretend that you (person A) are receiving a telephone call from person B. In this scene we see and hear only A (you) but not B. Using exactly the same dialogue (see the script on the following page), adapt your delivery and acting style to at least two of the following circumstances:

 a. B calls to tell you that she had her first novel published.

 b. B has quit her job.

 c. B has just wrecked your new car.

 d. B has called off the wedding.

 e. B has won big in the lottery.

 f. B has been arrested.

 g. B has lost her job.

 h. B has won an Emmy for innovative productions.

 Place the scene anywhere you like. You may do well to write the other part of the phone conversation so that you can listen and respond more convincingly.

 SECTION TOTAL []

<u>PHONE CONVERSATION</u>
Hello?
Hi.
Fine, and you?
Good.
No.
No, really. It's always a good time when you call.
I beg your pardon?
You must be kidding.
Yes.
No.
What does Chris say to all this?
No. Should I?
I don't know.
Perhaps.
You want me to come over now?
Yes. Really.
Well, this changes things somewhat.
I think so.
I'm not so sure.
Yes. No. I...
All right. But not...
OK.
If you think this is...
Definitely.
Good-bye...When?
No. Really.
Good-bye.

REVIEW OF CLOTHING AND MAKEUP

Select the correct answers and fill in the bubbles with the corresponding numbers.

1. For HDTV the smoothest makeup is (71) *water-based cake* (72) *grease base* (73) *spray-on foundation.*

 1 ◯ ◯ ◯
 71 72 73

2. Clothing with thin, highly contrasting stripes or checkered patterns is (74) *acceptable* (75) *not acceptable* because (76) *the CCD can handle such a contrast quite easily* (77) *it provides exciting patterns* (78) *it results in moiré color vibrations* (79) *it is too detailed for the camera to see.* **(Fill in two bubbles.)**

 2 ◯ ◯
 74 75
 ◯ ◯ ◯ ◯
 76 77 78 79

3. When doing makeup, you should have lighting conditions that are the same as or close to those of (80) *your customary makeup room* (81) *the actual production environment* (82) *normal 3,200K studio lights.*

 3 ◯ ◯ ◯
 80 81 82

4. The dress of a pop singer has many rhinestones that sparkle under the colored stage lights. This dress is (83) *acceptable* (84) *unacceptable* because (85) *the digital camera can handle small areas of extreme bright light* (86) *there is too much brightness contrast* (87) *it will result in moiré patterns* (88) *it will reinforce the stage lighting.* **(Fill in two bubbles.)**

 4 ◯ ◯
 83 84
 ◯ ◯ ◯ ◯
 85 86 87 88

5. During a green-backdrop chroma key, you should not wear (89) *red* (90) *blue* (91) *green* because this color will let the background show through during the key.

 5 ◯ ◯ ◯
 89 90 91

SECTION TOTAL []

REVIEW QUIZ

*Mark the following statements as true or false by filling in the bubbles in the **T** (for true) or
F (for false) column.*

		T	F

1. A close-up speeds up all movements. **1** ○ 92 ○ 93

2. When working with a teleprompter, it is best to move the camera as close as possible to the talent. **2** ○ 94 ○ 95

3. In a cross shot, you should stand on your mark even if you can't see the camera lens. **3** ○ 96 ○ 97

4. Because you never know what you will be asked to read in an audition, you should not prepare for it but can and should rely on the energy of the moment. **4** ○ 98 ○ 99

5. You can ignore the time cues by the floor manager so long as you can see the studio clock. **5** ○ 100 ○ 101

6. When on a close-up, you need to keep your actions tighter and slower than normal. **6** ○ 102 ○ 103

7. You should try to get the floor manager's attention when you think you should have received a time cue. **7** ○ 104 ○ 105

8. Because of possible moiré effects, you should avoid wearing high-contrast striped patterns on-camera. **8** ○ 106 ○ 107

9. In contrast to television performers, actors always portray someone else. **9** ○ 108 ○ 109

10. If you discover that you are talking to the wrong camera while using notes, you should look down and then look up into the on-the-air camera. **10** ○ 110 ○ 111

11. What you wear is really unimportant when simply auditioning for a role. **11** ○ 112 ○ 113

12. The best way to give an audio level is to quickly count to five. **12** ○ 114 ○ 115

13. The term *talent* refers to both actors and performers. **13** ○ 116 ○ 117

14. A "cut" cue from the floor manager means that the director is cutting (switching) to the next camera. **14** ○ 118 ○ 119

15. Like performers, actors make frequent use of the teleprompter. **15** ○ 120 ○ 121

SECTION TOTAL []

PROBLEM-SOLVING APPLICATIONS

1. The interviewer for the new weekly *Blues Review* show arrives in a bright red dress. She will interview the songwriter in the dimly lit backstage area of the house. Although the camera operator is using a small three-chip digital camcorder, he is somewhat concerned about the interviewer's attire. Why? What would you suggest?

2. The ENG camera operator is concerned about proper fill light for you, the reporter, during a live transmission of a traffic report on the fog-shrouded Golden Gate Bridge, so he asks for an additional person to handle the reflector. Do you share the camera operator's concern? If so, why? If not, why not?

3. The ENG camera operator suggests that you do your stand-up report right in front of the bright, sunlit wall of city hall. According to the camera operator, the automatic-iris control would guarantee a high-key lighting effect which, in turn, would reflect the upbeat story you have to tell. Do you agree with the camera operator? If so, why? If not, why not?

4. To practice blocking, write down a series of moves that carry you around your kitchen. For example, you can start at the stove, then get the teakettle out of the cupboard, put it on the stove, go back to pick up the telephone, put down the telephone to answer the door, and so forth. Try to hit the same marks each time you go through the routine. If possible, have a friend video-record your blocking maneuvers from the same camera position. You can then compare the recordings and check how accurate your blocking was. As part of the same exercise, you can use various props (kitchen utensils) and see how the camera's field of view (LS to ECU) will influence your handling of props.

5. Do your favorite monologue and video-record it (or, better, have someone else record it) first in a loose medium shot, then in a CU, and finally in an ECU. Analyze how the camera's field of view changes (or should change) your delivery and try to adjust your acting to each circumstance. Note especially the relative speed of your delivery and your facial expressions.

17 Putting It All Together: Directing

REVIEW OF KEY TERMS

Match each term with its appropriate definition by filling in the corresponding bubble.

1. multicamera directing
2. shot
3. single-column drama script
4. single-camera directing
5. camera rehearsal

6. visualization
7. take
8. time line
9. angle
10. fact sheet

11. dry run
12. walk-through/camera rehearsal
13. blocking
14. two-column A/V script

A. A combination orientation session and follow-up run-through with equipment

A
○ ○ ○ ○ ○
1 2 3 4 5
○ ○ ○ ○ ○
6 7 8 9 10
○ ○ ○ ○
11 12 13 14

B. Traditional television script format with both audio and video information

B
○ ○ ○ ○ ○
1 2 3 4 5
○ ○ ○ ○ ○
6 7 8 9 10
○ ○ ○ ○
11 12 13 14

C. Determining the positions and the actions of talent and equipment

C
○ ○ ○ ○ ○
1 2 3 4 5
○ ○ ○ ○ ○
6 7 8 9 10
○ ○ ○ ○
11 12 13 14

PAGE TOTAL []

1. multicamera directing	6. visualization	11. dry run
2. shot	7. take	12. walk-through/camera rehearsal
3. single-column drama script	8. time line	
4. single-camera directing	9. angle	13. blocking
5. camera rehearsal	10. fact sheet	14. two-column A/V script

D. The schedule of a production day

D
○1 ○2 ○3 ○4 ○5
○6 ○7 ○8 ○9 ○10
○11 ○12 ○13 ○14

E. Same as dress rehearsal

E
○1 ○2 ○3 ○4 ○5
○6 ○7 ○8 ○9 ○10
○11 ○12 ○13 ○14

F. Coordinating the simultaneous use of several cameras from the control room

F
○1 ○2 ○3 ○4 ○5
○6 ○7 ○8 ○9 ○10
○11 ○12 ○13 ○14

G. The basic approach to a story

G
○1 ○2 ○3 ○4 ○5
○6 ○7 ○8 ○9 ○10
○11 ○12 ○13 ○14

H. Rehearsal without equipment

H
○1 ○2 ○3 ○4 ○5
○6 ○7 ○8 ○9 ○10
○11 ○12 ○13 ○14

PAGE TOTAL []

© 2013 Cengage Learning

I. Traditional script format for television plays

I
○ ○ ○ ○ ○
1 2 3 4 5
○ ○ ○ ○ ○
6 7 8 9 10
○ ○ ○ ○
11 12 13 14

J. A list of features the talent should mention on-camera when demonstrating a product

J
○ ○ ○ ○ ○
1 2 3 4 5
○ ○ ○ ○ ○
6 7 8 9 10
○ ○ ○ ○
11 12 13 14

K. The mental image of a shot

K
○ ○ ○ ○ ○
1 2 3 4 5
○ ○ ○ ○ ○
6 7 8 9 10
○ ○ ○ ○
11 12 13 14

L. Guiding the use of a single camcorder for video-recording scripted events for postproduction

L
○ ○ ○ ○ ○
1 2 3 4 5
○ ○ ○ ○ ○
6 7 8 9 10
○ ○ ○ ○
11 12 13 14

M. The interval between two transitions

M
○ ○ ○ ○ ○
1 2 3 4 5
○ ○ ○ ○ ○
6 7 8 9 10
○ ○ ○ ○
11 12 13 14

N. Any one of similar repeated shots during video recording or filming

N
○ ○ ○ ○ ○
1 2 3 4 5
○ ○ ○ ○ ○
6 7 8 9 10
○ ○ ○ ○
11 12 13 14

PAGE TOTAL []

SECTION TOTAL []

REVIEW OF VISUALIZATION, CONTEXT, AND SEQUENCING

1. The following sketches show visualizations that change with different contexts. Fill in the bubbles that most closely match each visualization with its most appropriate context.

Set 1:

 15 16 17

 a. This can looks old—let's throw it away.

 b. Danger! This might be a bomb!

 c. This dogfood is rich in vitamins.

1a	○ 15	○ 16	○ 17
1b	○ 15	○ 16	○ 17
1c	○ 15	○ 16	○ 17

Set 2:

 18 19 20

 d. It handles like a sports car.

 e. As a luxury car, it is in a class by itself.

 f. It has a powerful engine.

1d	○ 18	○ 19	○ 20
1e	○ 18	○ 19	○ 20
1f	○ 18	○ 19	○ 20

SECTION TOTAL ▢

REVIEW OF INTERPRETING STORYBOARDS

1. Each of the following four storyboards shows one or several major problems. Fill in the bubbles whose numbers correspond with one or more of these major problems: (21) *poor continuity and disturbance of the mental map* (22) *wrong field-of-view designation* (23) *wrong above- or below-eye-level camera position.* (*Note: Storyboards may exhibit more than one problem.*)

Storyboard a Man and woman looking at each other

| CU of woman | Cut to: | CU of man | Cut to: | 2-shot | Cut to: | Tighter 2-shot |

1a ◯ 21 ◯ 22 ◯ 23

Storyboard b Runner finishing in first place

| CU of runner | Cut to: | LS of runner | Cut to: | MS of runner | Diss. to: | ECU of runner at finish |

1b ◯ 21 ◯ 22 ◯ 23

Storyboard c Teacher talking to girl

| Knee-shot of girl | Cut to: | MCU of teacher | Cut to: | Tight 2-shot | Cut to: | LS of teacher (profile) |

1c ◯ 21 ◯ 22 ◯ 23

Storyboard d Rock star talking to fan

| 2-shot of man and boy | Cut to: | CU of man | Cut to: | CU of boy | Cut to: | Low-angle shot of boy |

1d ◯ 21 ◯ 22 ◯ 23

SECTION TOTAL ☐

REVIEW OF SCRIPT MARKING

1. Match each field-of-view designation with its appropriate full term by filling in the bubble with the corresponding number.

(24) *cross-shot*
(25) *over-the-shoulder shot*

(26) *long shot*
(27) *extreme close-up*
(28) *medium shot*

(29) *extreme long shot*
(30) *close-up*

a. ELS

1a ○ ○ ○ ○
24 25 26 27
○ ○ ○
28 29 30

b. LS

1b ○ ○ ○ ○
24 25 26 27
○ ○ ○
28 29 30

c. ECU

1c ○ ○ ○ ○
24 25 26 27
○ ○ ○
28 29 30

d. X/S

1d ○ ○ ○ ○
24 25 26 27
○ ○ ○
28 29 30

e. O/S

1e ○ ○ ○ ○
24 25 26 27
○ ○ ○
28 29 30

f. MS

1f ○ ○ ○ ○
24 25 26 27
○ ○ ○
28 29 30

g. CU

1g ○ ○ ○ ○
24 25 26 27
○ ○ ○
28 29 30

PAGE TOTAL _____

Course No. _____ Date _____ Name _____

Select the correct answers and fill in the bubbles with the corresponding numbers.

2. The script markings in the following figure are (31) *acceptable* (32) *unacceptable* because they (33) *are too small* (34) *have unnecessary or redundant cues* (35) *are in the wrong place* (36) *show large, essential cues.* **(Fill in two bubbles.)**

2 ○ ○
 31 32

○ ○ ○ ○
33 34 35 36

JOHN

Ready camera 1
Ready to cue Tammy

What's the matter?

TAMMY

Cue Tammy and
take camera 1

Nothing.

JOHN

What do you mean, "nothing"? I can feel something is wrong.

TAMMY

Ready to cue John
Ready to take camera 2

Well, I am glad you have some feeling left.

JOHN

Cue John and take
camera 2

What's that supposed to mean?

TAMMY

Please, let's not start that again.

JOHN

Start what again?

TAMMY

Ready to take camera 3
for a two-shot

Well, I guess it's time to talk.

Take camera 3

JOHN

What do you think we have been doing all this time?

PAGE TOTAL []

SECTION TOTAL []

W-185

1. From the list below, select the director's visualization cue necessary to adjust the picture on the left screen to the picture on the right screen (in pairs from **a** through **l**) and fill in the bubbles with the corresponding numbers.

(37) *pan right*

(38) *tilt down*

(39) *truck right*

(40) *dolly out*

(41) *pedestal up or crane up*

(42) *pedestal down or crane down*

(43) *dolly in*

(44) *arc left*

(45) *zoom out*

(46) *zoom in*

(47) *pan left*

(48) *tilt up*

a.

1a

○	○	○	○
37	38	39	40
○	○	○	○
41	42	43	44
○	○	○	○
45	46	47	48

b.

1b

○	○	○	○
37	38	39	40
○	○	○	○
41	42	43	44
○	○	○	○
45	46	47	48

c.

1c

○	○	○	○
37	38	39	40
○	○	○	○
41	42	43	44
○	○	○	○
45	46	47	48

PAGE TOTAL

d.

Edward Aiona Edward Aiona

1d

○ 37	○ 38	○ 39	○ 40
○ 41	○ 42	○ 43	○ 44
○ 45	○ 46	○ 47	○ 48

e.

Edward Aiona Edward Aiona

1e

○ 37	○ 38	○ 39	○ 40
○ 41	○ 42	○ 43	○ 44
○ 45	○ 46	○ 47	○ 48

f.

Edward Aiona Edward Aiona

1f

○ 37	○ 38	○ 39	○ 40
○ 41	○ 42	○ 43	○ 44
○ 45	○ 46	○ 47	○ 48

g.

Edward Aiona Edward Aiona

1g

○ 37	○ 38	○ 39	○ 40
○ 41	○ 42	○ 43	○ 44
○ 45	○ 46	○ 47	○ 48

h.

Edward Aiona Edward Aiona

1h

○ 37	○ 38	○ 39	○ 40
○ 41	○ 42	○ 43	○ 44
○ 45	○ 46	○ 47	○ 48

```
P A G E
T O T A L   [        ]
```

CHAPTER 17 PUTTING IT ALL TOGETHER: DIRECTING

(37) *pan right*	(42) *pedestal down*	(45) *zoom out*
(38) *tilt down*	*or crane down*	(46) *zoom in*
(39) *truck right*	(43) *dolly in*	(47) *pan left*
(40) *dolly out*	(44) *arc left*	(48) *tilt up*
(41) *pedestal up or crane up*		

© 2013 Cengage Learning

2. From the list below, select the correct director's switching cues by filling in the corresponding bubbles. *(Multiple answers are possible.)*

2 ○ 49 ○ 50 ○ 51
○ 52 ○ 53 ○ 54

(49) *Ready to take camera two. Take camera two.*
(50) *Ready three. Take three.*
(51) *Ready one. Dissolve to one.*
(52) *Ready to go to black. Go to black.*
(53) *Ready wipe. Dissolve to two.*
(54) *Ready to change CG page. Change page.*

3. From the list below, select the correct director's cues to the floor manager by filling in the corresponding bubbles. *(The talent consists of two men and two women. Multiple answers are possible.)*

3 ○ 55 ○ 56 ○ 57
○ 58 ○ 59 ○ 60

(55) *Ready to cue Mary. Cue Mary.*
(56) *Ready to cue him. Cue him.*
(57) *Make him talk faster.*
(58) *Move her stage-right.*
(59) *Turn the can counterclockwise.*
(60) *Have two of them come closer to the camera.*

4. From the list below, select the director who uses the correct sequence of cues for the opening of a two-camera (C1 and C2) interview and fill in the corresponding bubble. *(There is a title key for the guest. Assume that the crew has received a general standby cue and that bars and tone have already been recorded on the tape by the AD.)*

4 ○ 61 ○ 62 ○ 63

(61) *Director A:* "Ready to take CG slate. Take slate. Ready black. Black. Beeper. Ready to come up on one CU of host—take one. Cue host. Ready two [on guest]. Take two. Cue guest. Key title. Take one."

(62) *Director B:* "Ready to roll VR. Roll VR. Ready CG slate. Read slate. Ready black. Ready beeper. To black. Beeper. Ready to come up on one. Key. Up on one. Ready two. Take two. Lose key. Ready one. Take one."

(63) *Director C:* "Ready to roll VR. Roll VR. Ready CG slate. Take CG. Read slate. Ready black. Ready beeper. To black. Beeper. One, CU of host. Ready to come up on one. Open mic, cue host, up on one. Two, CU of guest. Ready two. Ready to key CG. Take two, key. Lose key. Ready one, two-shot. Take one."

PAGE TOTAL

SECTION TOTAL

W-189

REVIEW OF REHEARSAL TECHNIQUES

Select the correct answers and fill in the bubbles with the corresponding numbers.

1. Blocking rehearsals are most efficiently conducted (64) *from the control room* (65) *on the studio floor or in a rehearsal hall* (66) *on the actual studio set.*

 1 ○ 64 ○ 65 ○ 66

2. Camera rehearsal is conducted (67) *similarly to a dress rehearsal* (68) *for cameras only* (69) *for all technical operations but without talent.*

 2 ○ 67 ○ 68 ○ 69

3. When engaged in EFP, you need not worry about (70) *talent and technical walk-throughs* (71) *cross-overs from one location to the next* (72) *the various camera positions.*

 3 ○ 70 ○ 71 ○ 72

4. If pressed for time, you should call for (73) *an uninterrupted camera rehearsal* (74) *a blocking rehearsal* (75) *a walk-through/camera rehearsal.*

 4 ○ 73 ○ 74 ○ 75

5. Rehearsals that combine walk-throughs and camera rehearsal are most efficiently conducted from the (76) *studio floor* (77) *rehearsal hall* (78) *control room.*

 5 ○ 76 ○ 77 ○ 78

SECTION TOTAL []

REVIEW QUIZ

*Mark the following statements as true or false by filling in the bubbles in the **T** (for true) or*
***F** (for false) column.*

		T	F

1. When marking a script, the ready cues must be written in just before the actual take cues. **1** ○ 79 ○ 80

2. When marking a script, you should always write in the ready cues. **2** ○ 81 ○ 82

3. The "notes" activity during a production requires scheduled time for the corresponding "reset." **3** ○ 83 ○ 84

4. When doing an EFP, uninterrupted camera rehearsals are more important than when doing a studio show. **4** ○ 85 ○ 86

5. A good floor plan will greatly facilitate camera and talent blocking. **5** ○ 87 ○ 88

6. When directing a daily newscast, you do not need a floor plan to preplan the camera shots. **6** ○ 89 ○ 90

7. Although the program objective is important to the director in the production phase, it is relatively unimportant in preproduction. **7** ○ 91 ○ 92

8. Because the director is engaged in artistic activities, knowledge of the technical production aspects is relatively unimportant. **8** ○ 93 ○ 94

9. Proper visualization is essential for correct sequencing. **9** ○ 95 ○ 96

10. If the script marking simply indicates "②" for the shot that is on the air and "③" for the next, it implies that you should give a "Ready three" cue and then call for a "Take three." **10** ○ 97 ○ 98

SECTION TOTAL []

PROBLEM-SOLVING APPLICATIONS

1. When asked to direct an on-location television adaptation of the current theater arts department stage play in the local park, you are advised by the theater director of the play that he will determine the number and the positions of the cameras because he, after all, knows the stage blocking better than you do. What is your reaction? What would you suggest?

2. You are to determine on-camera shots and mark a script for an involved scene of a three-camera, live-recorded situation comedy. The producer tells you that all she can give you is the script, not the complete floor plan. Because of a computer failure, the art director cannot transfer his rough sketch into a finished floor plan, and there is no way to get it to you before rehearsal. Can you proceed with your preproduction activities? If so, how? If not, why not?

3. When you're directing an EFP of a documentary segment on the lumber industry, the producer tells you not to worry too much about shot continuity because he intends to put the show together in extensive postproduction editing. Do you agree with the producer? If so, why? If not, why not?

4. During the evening news, the wrong story comes up on the server monitor. What can you do?

5. During an O/S sequence in a multicamera dramatic production, one of the actors has trouble hitting the blocking marks and is frequently obscured by the camera-near person. What advice would you give the actor?

Scale: ¼" = 1'

Property List

Scale: ¼" = 1'

Property List

Scale: ¼" = 1'

Property List

Scale: ¼" = 1'

Property List

CPSIA information can be obtained
at www.ICGtesting.com
Printed in the USA
FFOW02n1042220115
10502FF